WORLD
FILM
LOCATIONS
MARSEILLES

Edited by Marcelline Block

First Published in the UK in 2013 by
Intellect Books, The Mill, Parnall Road,
Fishponds, Bristol, BS16 3JG, UK

First Published in the USA in 2013
by Intellect Books, The University of
Chicago Press, 1427 E. 60th Street,
Chicago, IL 60637, USA

Copyright ©2013 Intellect Ltd

Cover photo: *Fanny* © 1961 Warner
Bros / The Kobal Collection / Limot

Copy Editor: Emma Rhys

A Catalogue record for this book is
available from the British Library

World Film Locations Series
ISSN: 2045-9009
eISSN: 2045-9017

World Film Locations Marseilles
ISBN: 978-1-84150-723-1
eISBN: 978-1-84150-804-7

Printed and bound by
Bell & Bain Limited, Glasgow

WORLD FILM LOCATIONS
MARSEILLES



EDITOR
Marcelline Block

SERIES EDITOR & DESIGN
Gabriel Solomons

CONTRIBUTORS
Elizabeth Abele , Adrienne Angelo,
Henri-Simon Blanc-Hoàng,
Marcelline Block, Olivier Bohler,
Oana Chivoiu, Georgiana M. M. Colvile,
Jez Conolly, Sandy Flitterman-Lewis,
Marco Grosoli, Kristiina Hackel,
Scott Jordan Harris, Andrew Howe,
Zachary Ingle, Annette Insdorf,
Nathalie Katinakis, Jean-Luc Lioult,
Lance Lubelski, Rebecca Prime,
Zachariah Rush, Pamela C. Scorzin,
Steven Ungar, Katherine A. Wagner,
Tina Wasserman

LOCATION PHOTOGRAPHY
Gabriel Solomons and Jean-Luc Lioult
(unless otherwise credited)

LOCATION MAPS
Joel Keightley

PUBLISHED BY
Intellect
The Mill, Parnall Road,
Fishponds, Bristol, BS16 3JG, UK
T: +44 (0) 117 9589910
F: +44 (0) 117 9589911
E: info@intellectbooks.com

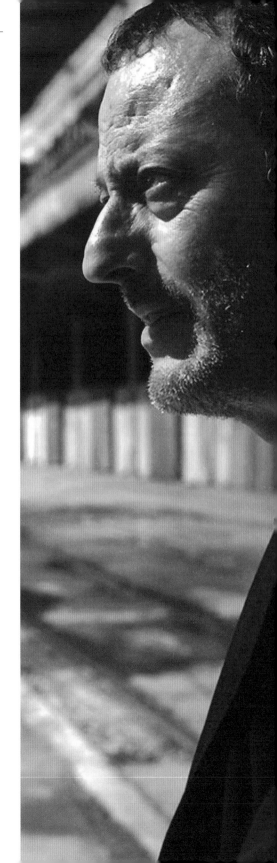

CONTENTS

DEDICATION AND ACKNOWLEDGEMENTS

I wish to most gratefully acknowledge my immense indebtedness to Gabriel Solomons, series editor of *World Film Locations*, for his exceptional guidance and inspirational leadership at every step of the editorial process of this volume. Without him, it would not have happened. My gratitude goes to Masoud Yazdani and everyone at Intellect as well as at the University of Chicago Press who most thoroughly oversaw this publication, especially James Campbell, Amy Damutz, Melinda Kennedy, Melanie Marshall and May Yao. A very special thank you to Gabriel Solomons and Jean-Luc Lioult for their wonderful location photography of Marseilles. Thanks are also due to Olivier Bohler and Françoise Dravet for lending insight into their hometown of Marseilles, and finally to the outstanding group of contributors for their dedication to and enthusiasm for the films made in the Phocaean City.

MARCELLINE BLOCK

INTRODUCTION

World Film Locations Marseilles

MARSEILLES, AWARDED THE TITLE of European Capital of Culture for the year 2013, 'has a statistically significant presence' (Reader, p. 6) in French cinema. It has been said that the New Wave was born on Marseilles' Vieux-Port – the starting point of Jean-Luc Godard's *A bout de souffle/Breathless* (1960).

In this volume, 46 film scene reviews – along with seven essays – traverse Marseilles cinematically. Like Chicago in the US, Marseilles has been called France's 'second city'. Crime, endemic to filmic representations of these two cities, stamps them as loci of violence, emblematized by *Justin de Marseille* (Maurice Tourneur, 1935). Jean-Jacques Beineix's tale of rape, suicide, and revenge, *La Lune dans le caniveau/The Moon in the Gutter* (1983) created a dark, surreal vision of Marseilles filmed in Cinecittà studios, winning the César for Best Production Design.

The French Connection (William Friedkin, 1971) – the first R-rated Best Picture – based on true events and partially shot in Marseilles, has a fictitious sequel, *The French Connection II* (John Frankenheimer, 1975), entirely set there. These films depict narcotics trafficking between Marseilles and New York, whereas *Mains armées/Armed Hands* (Pierre Jolivet, 2012) tracks an international drug/gun ring from Marseilles to Paris, lifelong rival cities.

Marcel Pagnol's iconic trilogy – *Marius* (Alexander Korda, 1931), *Fanny* (Marc Allégret, 1932), *César* (Marcel Pagnol, 1936) – inaugurated a Marseilles mythology that forms the antithesis of gangster films. This trilogy, based on traditional values, showcases idiosyncrasies of southern French culture: the meridional accent accompanied by gesticulation, Provençal specialty cooking featuring *bouillabaisse*, card games such as *belote* or the outdoor ball game *pétanque*.

Pagnol's narratives have cross-Atlantic appeal, first remade in English as *Port of Seven Seas* (James Whale, 1938), then as the 1954 Broadway musical *Fanny*, produced by David Merrick and adapted to screen by Joshua Logan in 1961. Actor/director Daniel Auteuil is remaking Pagnol's trilogy, whose cast includes Ariane Ascaride, a member of Marseillais director Robert Guédiguian's troupe. Ascaride and Guédiguian are interviewed in the concluding essay of this volume.

Pagnol's archetypal figures are reinscribed within Marseilles' film canon: in Ridley Scott's *A Good Year* (2006), a character named Fanny (Marion Cotillard) evokes the one from Pagnol's trilogy. Guédiguian's *Marius et Jeannette* (1997) – for which Ascaride won the César – reminds us of Pagnol's own *Marius*, while Honorine, who is the mother of Fanny in Pagnol's trilogy, is the name of an elderly woman in Alain Bévérini's *Total Khéops/Total Chaos* (2002; adapted from Marseilles-born author Jean-Claude Izzo's novel).

Discussed herewith are the *calanques*; the winding streets of the Panier; Saint-Charles train station; Notre-Dame de la Garde; the Vieux-Port; and l'Estaque, a seaside village immortalized by Paul Cézanne. The bustling Canebière is sung and praised in the *opérette marseillaise Un de la Canebière/One from the Canebière* (Maurice Poggi, 1935), which boasts that this boulevard 'goes around the world', an example of the southern French propensity for exaggeration. Jean Renoir's film *La Marseillaise* (1938) includes the eponymous French national anthem in its narration of the beginning of the French Revolution. Longtime resident of Marseilles Edith Piaf is shown, as a young girl, singing 'La Marseillaise' in Olivier Dahan's film *La vie en rose* (2007). *Les marins perdus/The Lost Sailors* (Claire Devers, 2003) briefly features a plaque commemorating Marseilles' Resistance during World War II. Wreckage from the French writer Antoine de Saint-Exupery's airplane – which disappeared over the Mediterranean during an anti-Nazi mission in 1944 – was later recovered, along with his possible remains, off the Marseilles coast. Another celebrated French author, poet Arthur Rimbaud, died in Marseilles in 1891, while attempting to travel to Africa.

Steven Ungar's discussion of 'Marseilles in its own light' invokes the motto: 'by her great deeds, the city of Massilia (Marseilles) shines'. ✢

Marcelline Block, Editor

NOTE TO THE READER: *Throughout the book we have used the English spelling of the city's name 'Marseilles' with the exception of location information and French film titles which retains the French spelling 'Marseille'.*

MARSEILLES

City of the Imagination

Text by
STEVEN
UNGAR

MARSEILLES IS OFTEN DISMISSED as France's second city, forever in Paris' shadow. This dismissal is particularly unjust because, like Lyon, Marseilles' role in film history is distinctive. Lyon's began in 1895 with Louis Lumière's *La Sortie des usines Lumière à Lyon/Employees Leaving the Lumière Factory*, often considered the first motion picture. Views of Marseilles' Vieux-Port and Canebière supplement *L'Arrivée d'un train en gare de La Ciotat/The Arrival of a Train at La Ciotat* (1895), shot by Louis and Auguste Lumière 20 miles to the south-east. Location shooting was central to *Cœur fidèle/True Heart* (Jean Epstein, 1923), whose stark depiction of Marseilles' working-class waterfront turned its melodrama of a long-suffering barmaid in love with a dockworker into a precursor of 1930s poetic realist films. Among them, Marseilles is the destination of the ocean liner departing Algiers at the end of *Pépé le Moko* (Julien Duvivier, 1937). That year, Marseilles is also the de facto end point of Edmond (Louis Jouvet) and Renée's (Annabella) failed flight to Egypt in *Hôtel du Nord* (dir. Marcel Carné). That the sequences in Carné's film were shot on a sound stage demonstrates Marseilles' importance as a colonial metropolis and port of call for points south and east. When Stephen

Heath dubs Marseilles the 'door of the fatherland', opening onto its overseas empire, he confirms the cosmopolitan sense of the colonial-era port city evoked through articles Albert Londres republished as *Marseille, Porte du Sud* (1926).

The Marseilles in Pagnol's trilogy – *Marius* (Alexander Korda, 1931), *Fanny* (Marc Allégret, 1932) and *César* (Marcel Pagnol, 1936) – remains definitive in light of what Ginette Vincendeau terms the shifting attributes of 'Marseillais-ity' across characters and situations. Sequences filmed in and around the Vieux-Port transform everyday gestures – Marius looking out his window at ships in the harbour, Fanny at her fish stand, César walking through the port to inform the priest of Panisse's imminent death – into elements of an imagined community whose persistence among generations of French spectators borders on the mythic. Like the *santons* (small figures) traditionally crafted in Aubagne, Pagnol's nearby home town, the trilogy defines Marseilles as city of the imagination on regional/national scales. (Think France's equivalent of the aura radiated by *Gone with the Wind* [Victor Fleming, 1939] among American viewers.) Even among detractors who reduce it to little more than filmed theatre, Pagnol's trilogy remains the measure with which subsequent cinematic depictions of Marseilles contend. Joshua Logan's remake of *Fanny* (1961), starring Charles Boyer, Maurice Chevalier and Leslie Caron, only heightens the extended afterlife of Pagnol's Marseilles across generations, genres and national practices.

The emotional warmth of Pagnol's trilogy obscures a concurrent vision of Marseilles as site of violence and crime. This second perspective, already evident in Epstein's *True Heart*, and marginal in Pagnol's *César*, builds on a Chicago-Marseilles parallel. *Justin de Marseille* (Maurice Tourneur, 1935) recalls early American sound-era gangster films centred upon a charismatic figure in urban settings, including 1931's *Public Enemy* (dir.

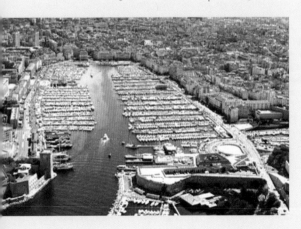

William Wellman) and *Little Caesar* (dir. Mervyn
LeRoy). Yet Tourneur's take on the lead figure's
criminality is subsumed within a personal elegance
that, as in the film's title, extends to the city. As
explained by a resident, the low life of Marseilles is
also its high life because, among its gangsters who
behave with style, Justin is the most stylish. As in
the pseudo-documentary of the Algiers kasbah in
Pépé, *Justin* features shots of street life where crime
was tolerated as a daily fact of urban existence.
Thirty-five years later, motifs of crime and
elegance take on period detail in *Borsalino* (1970),
Jacques Deray's buddy movie, whose title evokes
interwar Marseilles through the upscale brand of
fedora worn by protagonists Capella (Jean-Paul
Belmondo) and Siffredi (Alain Delon). Grittier
takes on local crime in films from *The French
Connection* (William Friedkin, 1971) to *The Bourne
Identity* (Doug Liman, 2002) and *The Transporter*
(Louis Leterrier & Corey Yuan, 2002) solidified
Marseilles' cinematic reputation within a global
action film market. Jean-Luc Godard was likely
thinking Marseilles-Chicago when Belmondo's
Michel Poiccard steals an Oldsmobile from the
Vieux-Port in *A bout de
souffle/Breathless* (1960).
Yet Godard's perspective
on the Vieux-Port
seems reductive when
compared to *Total
Khéops/Total Chaos*
(Bévérini, 2002), adapted
from Marseillais novelist
Jean-Claude Izzo's neo-
noir trilogy.

Marseilles in Robert

> Even among
> detractors who
> reduce it to little
> more than filmed
> theatre, Pagnol's
> trilogy remains the
> measure with which
> subsequent cinematic
> depictions of
> Marseilles contend.

Guédiguian's films first appears as updated versions
of Pagnol's, sharing a repertory theatre approach that
sets fixed troupes of actors within accounts of daily
life in working-class areas in/surrounding his home
town. Guédiguian's *Marius et Jeannette* (1997) recasts
Pagnol's melodrama as a romance set in l'Estaque,
a fishing village on Marseilles' outskirts. *Les neiges
du Kilimandjaro/The Snows of Kilimanjaro* (Robert
Guédiguian, 2011) revisits this milieu in depicting a
working-class couple – Guédiguian regulars Ariane
Ascaride and Jean-Pierre Darroussin – whose
peaceful lives in semi-retirement are shattered
by a burglary. This intrusion of violence aligns
Kilimanjaro with the grim realism of Marseilles-
Chicago and politically-engaged films such as *Le
rendez-vous des quais/Meeting on the Docks* (Paul
Carpita, 1953) and *Retour à Marseille/Return to
Marseilles* (René Allio, 1980). Guédiguian probably
chose the title *Marius and Jeannette* to resonate
with the first film in Pagnol's trilogy. Yet, along with
Kilimanjaro, it reminds us that Guédiguian, whose
father worked on the docks, identifies as a leftist
Marseillais film-maker balancing a predilection for
a warm realism of human relations with an equal
commitment to sociopolitical justice.

Another vivid account of local politics is
*Marseilles contre Marseille/Marseilles Against
Marseilles* (1989–2002), seven documentaries
filmed by Jean-Louis Comolli (assisted by Michel
Samson) – a tragicomic chronicle of the city.
Moving from the urgency of a new local politics
precipitated by socialist mayor Gaston Deferre's
death, the rise of National Front right-wing
extremism and emerging political clout among
immigrants, the final film, *Rêves de France à
Marseille/Dreams of France in Marseilles* (2003),
celebrated the transition from social integration
among ethnic minorities/women who had yielded
to a true political presence. As a result, Marseilles
is forerunner of a new France, in which racism and
sexism were replaced by 'rainbow' coalitions.

Contemporary Marseilles in Guédiguian and
Comolli confirms the rise of *beur* and francophone
cultures among first- and second-generation
children of immigrants from France's one-time
colonies. In *Bye-Bye* (Karim Dridi, 1995), Marseilles
is no longer simply France's door to its colonial
empire, but also a gateway for those arriving in
France from its former African colonies. No longer
a *port* (port) nor *porte* (door) to the overseas south,
since 1990 Marseilles on-screen is increasingly
understood on its own terms, in its own light. ✢

MARCEL PAGNOL'S MARSEILLES

Text by
REBECCA
PRIME

Marius, Fanny, César

PAGNOL AND PROVENCE. Popular cinematic adaptations of Marcel Pagnol's novels – including Claude Berri's *Jean de Florette* and *Manon des sources/Manon of the Spring* (both 1986) and the most recent Pagnol remake, *La fille du puisatier/ The Well-Digger's Daughter* (Daniel Auteuil, 2011) – have made Pagnol synonymous with the sun-soaked Provençal landscape. However, Pagnol (1895-1974) – author, dramatist, film-maker – in his initial forays into cinema showcased not so much the countryside, but rather, Marseilles, the city of his childhood. Born in the nearby town of Aubagne in 1895, Pagnol's family relocated to Marseilles when he was 5 years old, where he would spend much of his working adult life. His Marseilles trilogy – *Marius* (Alexander Korda, 1931), *Fanny* (Marc Allégret, 1932) and *César* (Pagnol, 1936) – established the city's cinematic and cultural image for decades to come, and remains prominent in France's national

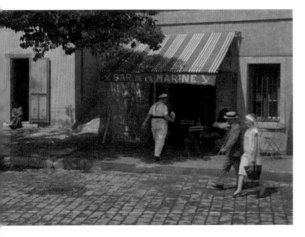

imagination: the series is currently being remade in its entirety by actor/director Daniel Auteuil.

Pagnol wrote the play upon which *Marius* was based while living 'in exile' in Paris, working as an English teacher before achieving rapid success in the theatre. The product of his nostalgic longing, *Marius* is imbued with distinct local flavour that Pagnol felt would not be understood or appreciated outside of Marseilles. Yet the play was a smash with Parisian audiences. It contributed to the vogue for Marseilles and the south's regional culture that took hold of France in the 1930s. With the advent of sound, film audiences could indulge their fascination with the southern accent known as *l'accent du midi*, while recordings and sheet music marketed Marseilles' vibrant music hall tradition to a broader, Parisian public. The play and film adaption of *Marius* featured a cast of performers drawn largely from this tradition, including Raimu as César, Orane Demazis as Fanny and Charpin in the role of Panisse. The Parisian Pierre Fresnay as Marius was the exception – all the more notable for his mastery of the southern accent.

A production of Paramount's European branch, *Marius* was filmed primarily at their studios on the outskirts of Paris. The balance between studio interiors and on-location exteriors was to change significantly in *Fanny* and *César*, with over a quarter of *César* being shot on location in Marseilles. This shift was facilitated by Pagnol's relocation to Marseilles, where he formed la Société des Films Marcel Pagnol in 1934. In addition to this production and distribution company, he established his own production facilities, consisting initially of a small studio and processing lab, soon expanding to include several sound stages, editing and viewing rooms, as well as administrative

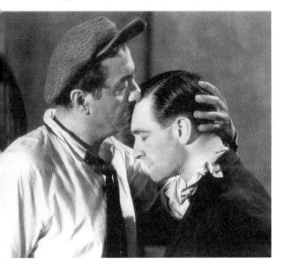

offices. Pagnol used his success as a playwright to guarantee his independence as a film-maker; in addition to writing and producing, he added directing to his résumé with *César*. And by choosing to work outside of Paris, the centre of French film industry, Pagnol aligned himself with Marseilles' rich cinematic history. The Lumière brothers had made a number of films in Marseilles, which became a centre for film production during the 1920s, as its mild climate and consistent sunshine earned it the moniker 'the French Los Angeles'.

The opposition between Paris and the 'second city' of Marseilles – with its rival urban culture – is inscribed in the Marseilles trilogy on numerous levels, including in the films' themes and performances. In *Marius*, César – Marius' father and the trilogy's voice of tradition – cannot understand his son's longing to experience life outside of Marseilles' Vieux-Port. When he learns that Marius has signed up for five years service aboard the Malaisie, he questions why anyone would want to go to sea since you can't play *boules* on a ship. When Fanny learns she is pregnant with Marius' child, César accepts her shotgun marriage to Panisse, a wealthy merchant 30 years her senior. Despite his chagrin at being

> **The opposition between Paris and the 'second city' of Marseilles – with its rival urban culture – is inscribed in the Marseilles trilogy on numerous levels, including in the films' themes and performances.**

unable to acknowledge his grandson as his own, César understands that Fanny must protect her family's honour above all. Upon Marius' unexpected return two years later, César convinces him to leave Fanny alone for the good of their son, Césariot, who will be given a better life by Panisse. Ironically, it is through Césariot that the contrast between the local culture of Marseilles and the national culture of Paris becomes most evident. In *César*, the last film in the trilogy, Césariot is a young man who has been educated at Paris' finest schools. He does not have his family's *accent du midi*, speaking instead with a Parisian accent that denotes his education and difference from them. Likewise, through his wardrobe and the sophisticated art deco furnishings of his bedroom, Césariot seems more representative of Parisian high society than of the regional culture expressed through the other characters' southern accents and exaggerated theatrical gestures.

Despite the visual and thematic prominence given to Marseilles' Vieux-Port, which serves as the location of César's Bar de la Marine, Panisse's business, Fanny's cockle stand, and much of the action throughout the trilogy, the depiction of the city is resolutely anachronistic. Unlike earlier films set in Marseilles, such as Louis Delluc's *Fièvre/ Fever* (1921) and Jean Epstein's *Cœur fidèle/True Heart* (1923), Pagnol refuses to acknowledge the seedier realities of the Vieux-Port, with its bars and brothels. And while the films of the Pagnol trilogy were made during a period of increased immigration to the region – as Jean Renoir called attention to in *Toni* (1934), which Pagnol produced – the homogenous cast of characters that populate Pagnol's Vieux-Port does not reflect a city with a substantial immigrant population (of over 20 per cent).

Significantly, *César* concludes in the countryside. Reunited by César, Fanny and Marius walk together down a country lane having finally agreed to marry – the trilogy's only possible conclusion. Perhaps because of the growing chasm between his vision of the Marseilles of his childhood and the city's contemporary reality, Pagnol's subsequent films replaced the 'village' of the Vieux-Port with the real villages of Provence's backcountry. However anachronistic, Pagnol's affectionate vision of Marseilles has a lasting appeal, inspiring other 1930s films in the 'Marseilles comic genre' along with Joshua Logan's 1961 remake *Fanny* (which combined all three films into one), and the Daniel Auteuil remakes currently in production. ✣

MARSEILLES

maps are only to be taken as approximates

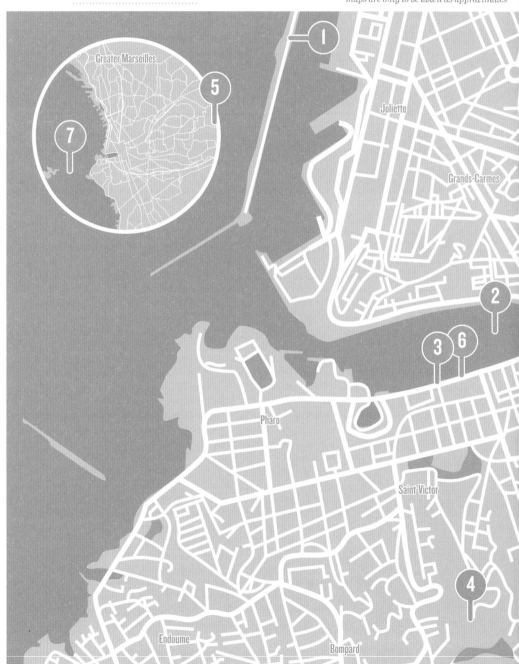

Greater Marseilles

Joliette

Grands-Carmes

Pharo

Saint-Victor

Endoume

Bompard

MARSEILLES LOCATIONS
SCENES 1-8

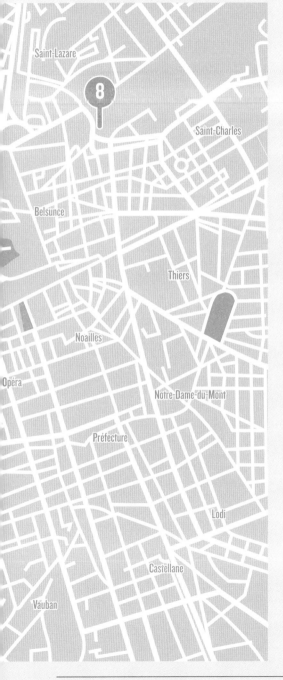

1.
TRUE HEART/CŒUR FIDÈLE (1923)
Digue Sainte-Marie, Vieux-Port
page 12

2.
IMPRESSIONS OF THE OLD
MARSEILLES HARBOR/
IMPRESSIONEN VOM ALTEN
MARSEILLER HAFEN (1929)
Pont transbordeur (transporter bridge) and
Vieux-Port (bridge destroyed in 1944)
page 14

3.
MARIUS (1931)
Imaginary location of 'Le Bar de la Marine',
Vieux-Port, Quai de la Rive Neuve –
filmed in a studio
page 16

4.
FANNY (1932)
Notre-Dame de la Garde Basilica,
Rue Fort-du-Sanctuaire
page 18

5.
CIGALON (1935)
Restaurant 'Le Cigalon' in La Treille,
9 boulevard Louis Pasteur
page 20

6.
CÉSAR (1936)
Vieux-Port, Quai de la Rive Neuve
page 22

7.
THE MARSEILLAISE/
LA MARSEILLAISE (1938)
Château d'If, Embarcadère Frioul If,
1 Quai de la Fraternité
page 24

8.
ODETTE/ODETTE, AGENT S.23 (1950)
Staircase of the Marseille-Saint-Charles
Train Station, Square Narvik
page 26

TRUE HEART/CŒUR FIDÈLE (1923)

LOCATION *Digue Sainte-Marie, Vieux-Port*

ALTHOGH JEAN EPSTEIN (1897–1953) is perhaps not familiar to most modern film lovers, he was nonetheless one of the greatest film critics, theorists and directors working in the silent era. *True Heart* is his masterpiece, a stunning work of French film impressionism, and the best encapsulation of Epstein's theories of *photogénie*. Epstein felt – as did many in the first French avant-garde – that film was a modern seventh art that opened up a new, breathtaking world to the viewer. Epstein believed that the camera could reveal, through uniquely cinematic methods – such as the close-up, the iris, rhythm, and movement – the soul of people and objects. The photogenic power of the cinematographic image was the focus of his writings and *The True Heart* attests to his ability to compose those images as well as describe them. *The True Heart* narrates the love story of barmaid Marie (Gina Manès) and semi-employed dockworker Jean (Léon Mathot). However, Marie is forced by her adoptive parents to marry the drunken ruffian, Petit Paul (Edmond van Daële). *The True Heart* is a melodrama that ends unexpectedly happily with faithful love rewarded. In this scene, while Petit Paul loiters nears the boats, Marie hurries to meet Jean in their special spot on the Sainte-Marie breakwater near the lighthouse, so they can snatch a few moments together. She adjusts her hair in a scratched mirror and then joins Jean, where the two sit lovingly by the sea, looking out over the Vieux-Port with the Palais du Pharo in the distance. **•Kristiina Hackel**

Photo © Gabriel Solomons

Directed by Jean Epstein
Scene description: *The two lovers, Marie and Jean, snatch some time together*
Timecode for scene: *0:07:15 – 0:12:13*

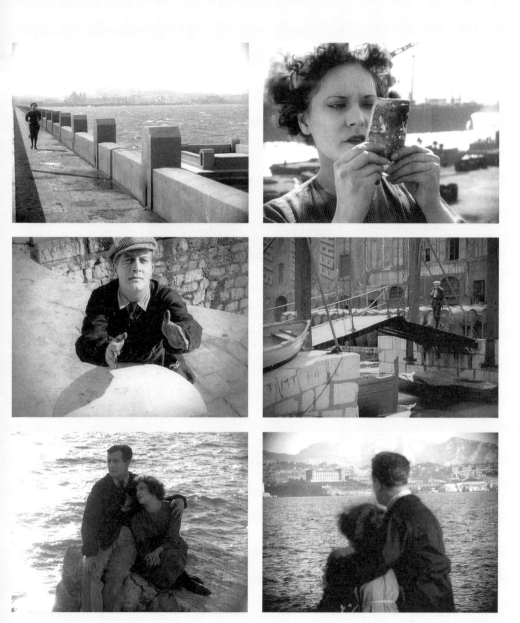

Images © 1923 Pathé Consortium Cinéma

IMPRESSIONS OF THE OLD MARSEILLES HARBOUR/
IMPRESSIONEN VOM ALTEN MARSEILLER HAFEN (1929)

LOCATION *Pont transbordeur (transporter bridge) and Vieux-Port (bridge destroyed in 1944)*

IN *IMPRESSIONS OF THE OLD MARSEILLES HARBOR*, Hungarian artist and film-maker László Moholy-Nagy (1895–1946) focuses his documentary lens on the advanced technological structure of the transporter bridge positioned in the ancient harbour of the Vieux-Port. The transporter bridge stands as an edifice of promise, technological advancement and twentieth-century progress. However, alongside this great advancement for the city of Marseilles, Moholy-Nagy gives equal screen time to images showing its squalor, poverty and deprivation. From images of the gentry, he cuts to a vaguely conscious vagrant drooling on himself; from the intricate and abstractly expressionistic patterns of the bridge's steel girders, Moholy-Nagy cuts to detritus. Moholy-Nagy's impression of Marseilles is steered by an obvious class-consciousness. The gap between the privileged and the underprivileged in Marseilles seems, as it does everywhere, perennially unbridgeable. And yet it is just such dreams of privilege and prosperity that entices fresh new life into a city like Marseilles. One is reminded of the image in Apollinaire's 'The Door'/'La porte,' where he writes, 'fresh angels who have arrived in Marseilles the morning before'. In this ten-minute film, Moholy-Nagy would ostensibly offer images of a bridge in Marseilles but, perhaps less intentionally, he offers a glimpse of that which he finds unbridgeable in Marseilles... **•→ Zachariah Rush**

Photo © Gabriel Solomons

Directed by Lázló Moholy-Nagy
Scene description: The class divide of a city on the rise
Timecode for scene: 0:00:00 – 0:10:30 (entire film)

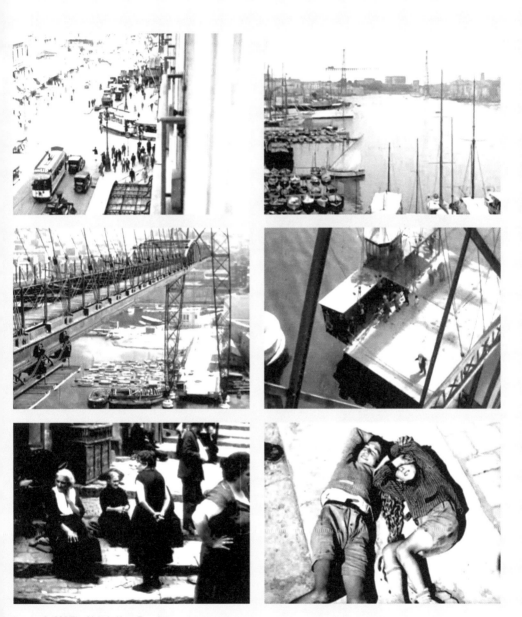

MARIUS (1931)

Imaginary location of 'Le Bar de la Marine', Vieux-Port, Quai de la Rive Neuve – filmed in a studio

ALL THE ACTION OF *Marius* takes place in a specific setting: the Old Port of Marseilles, which is the historic centre of the town and one of Marseilles' best known symbols. *Marius*, the first film in the Pagnol trilogy, is indeed limited to the heart of the city, as if Marseilles were only a small area that could be scanned in minutes. This location is confined to the borders of the neighbourhood, and the characters of the story only take the boat to go to the other side of the shore. More precisely, *Marius'* narrative comes alive in Le Bar de la Marine located on the unique Quai de la Rive Neuve, where its owner, César (Raimu), and his son, Marius (Pierre Fresnay), work together. The motley group of characters reunite in this central spot to confront each other or to simply discuss their daily worries. The scene of the *la partie de cartes* (card game) symbolizes the film's essence, although it does not advance the action. Yet it is helpful to attain a better understanding of the characters' psyches. As César, Escartefigue (Paul Dullac), Panisse (Charpin) and Mr. Brun (Robert Vattier) are playing cards, *la manille*, César tries to reveal to his partner, Escartefigue, what he should play by exclaiming, in his thick *accent du Midi*, 'Tu me fends le coeur!' ('You break my heart!'). An angry Panisse, suspecting that cheating has occurred, leaves the room in protest.
⬦ Nathalie Katinakis

Directed by Alexander Korda
Scene description: *A game of cards at 'Le Bar de la Marine'*
Timecode for scene: *1:11:22 – 1:14:32*

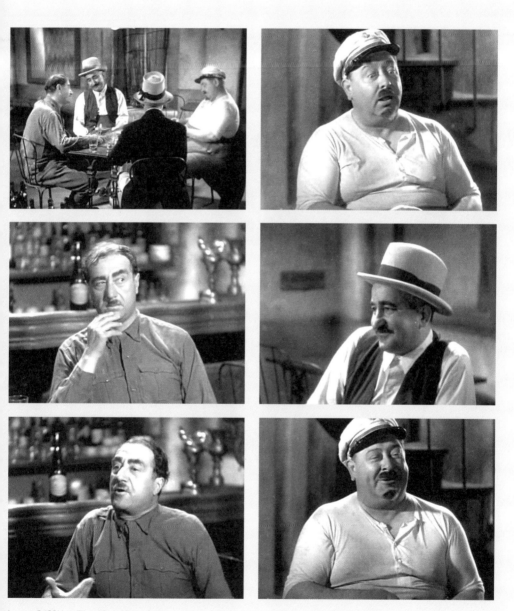

Images © 1931 Les Films Marcel Pagnol

FANNY (1932)

LOCATION *Notre-Dame de la Garde Basilica, Rue Fort-du-Sanctuaire*

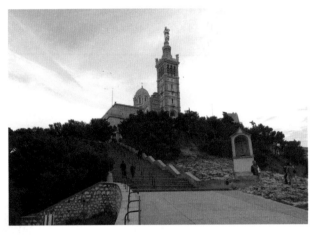

THIS SECOND PART of Pagnol's Marseilles trilogy shows us new filming locations, such as Notre-Dame de la Garde basilica, where Fanny (Orane Demazis) goes to pray when a visit to the doctor confirms her pregnancy. Shot on location, this scene follows Fanny when she crosses Marseilles and climbs the stairs to the top of the hill overlooking the city where the famous basilica stands. This scene reflects well how the morality of the time was based on principles from the popular rural tradition, in which religion played a central role. Notre-Dame de la Garde, familiarly called the 'La Bonne Mère' ('The Good Mother'), is known as the Virgin of fishermen, but also of all the people of Marseilles. It protects the city and its inhabitants. In *Fanny*, as well as in *Marius* (Alexander Korda, 1931) and *César* (Marcel Pagnol, 1936), this basilica is constantly evoked by the characters in their everyday expressions. At that time, being a single mother was considered a disgrace. Women in this situation were rejected by their families and were frowned upon by the others. For this reason, when Fanny finds out that she's pregnant by Marius (Pierre Fresnay) – who has left her for distant lands – she's completely desperate. Her first reaction is to take shelter at Notre-Dame de la Garde to pray. On her knees and crying, she implores the Blessed Virgin Mary to bring Marius back to her so he can give a name to her child. **Nathalie Katinakis**

Directed by Marc Allégret
Scene description: Fanny goes to Notre-Dame de la Garde to pray
Timecode for scene: 0:42:21 – 0:43:50

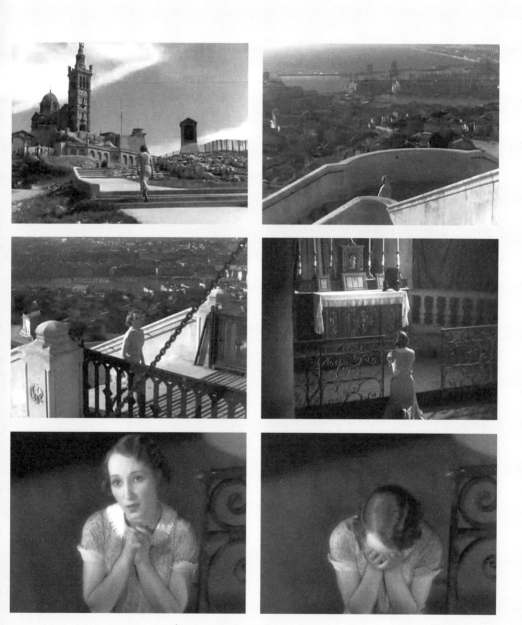

CIGALON (1935)

Restaurant 'Le Cigalon' in La Treille, 9 boulevard Louis Pasteur

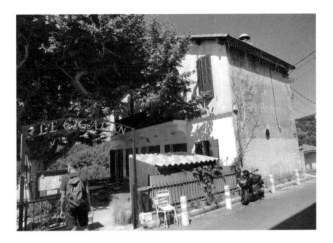

CIGALON WAS SHOT ON LOCATION in the real restaurant of the same name that still exists in the heights of La Treille in the 11th *arrondissement* of Marseilles. The entire movie is filmed in the surroundings of this Provençal restaurant, well known for its traditional recipe of *pieds parquets* (tripe and trotters) from 1896. This particular scene sets the tone of the rest of the film. As customers are seated at the restaurant terrace, waiting to eat, they beg Cigalon (Alexandre Arnaudy), the grumpy chef, to prepare them a meal, but he refuses. Although the place is actually a restaurant, Cigalon doesn't want to cook for anyone other than his sister and himself. He loves his food so much that he considers his customers unworthy of it. Since his reputation precedes him, he doesn't see the point of cooking for others. This comic introduction shows us the explosive, snooty and colourful personality of Cigalon, who is not afraid to mistreat his customers, although his rude attitude will turn against him later when Mme. Toffi (Marguerite Chabert) will open another restaurant in the village. It's also a perfect example of the comedic verbal jousting typical of Marcel Pagnol's work. If La Treille is now part of the big city of Marseilles, it was just a village in the 1930s. That's why the setting of *Cigalon* is not urban: there are few people and a country feel, and this movie therefore shows us a more rural aspect of Marseilles. **•◦Nathalie Katinakis**

Directed by Marcel Pagnol
Scene description: *Cigalon refuses to serve clients at his restaurant*
Timecode for scene: *0:01:50 – 0:08:43*

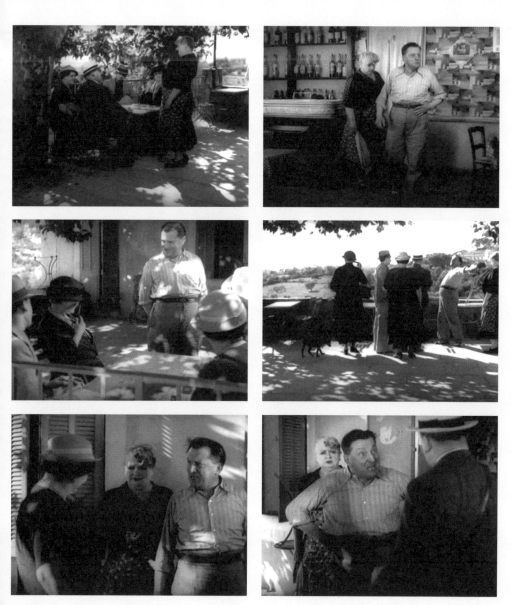

CÉSAR (1936)

LOCATION

Vieux-Port, Quai de la Rive Neuve

EVEN IF THIS THIRD PART of Marcel Pagnol's Marseilles trilogy is not only focused on Marseilles – with many scenes filmed in Toulon – the Old Port remains at the centre of the plot again. As she had to say goodbye to her true love when he left to become a sailor in *Marius* (Alexander Korda, 1931), Fanny (Orane Demazis) is also confronted with a departure in *César* when her son Césariot is leaving for a little trip on the sea. Although Césariot (André Fouché) is not going far away, Fanny is worried and hires the captain to act as a spy. This way, she can track all his comings and goings. Following in the footsteps of her mother, Honorine (Alida Rouffe), Fanny is repeating the pattern of being an overprotective parent. Shot on location, this outdoor scene gives us a good overview of the Old Port and the small shops surrounding it. As the boat takes off, Honorine calls her grandson through her window. Filmed from her point of view, we discover the Old Port with all the buildings on the Quai du Port, opposite the Quai de la Rive Neuve. Many of them were destroyed during World War II, except the town hall of Marseilles that stands on the right in this scene. Since then, new buildings were constructed to replace the old ones, and a few archives remain to remember how the Old Port used to be, like this movie by Marcel Pagnol and this particular scene that has a documentary feel. **Nathalie Katinakis**

Photo © Jean-Luc Lioult

Directed by Marcel Pagnol
Scene description: *Fanny says goodbye to her son Césariot on the Old Port of Marseilles*
Timecode for scene: *1:08:05 – 1:12:13*

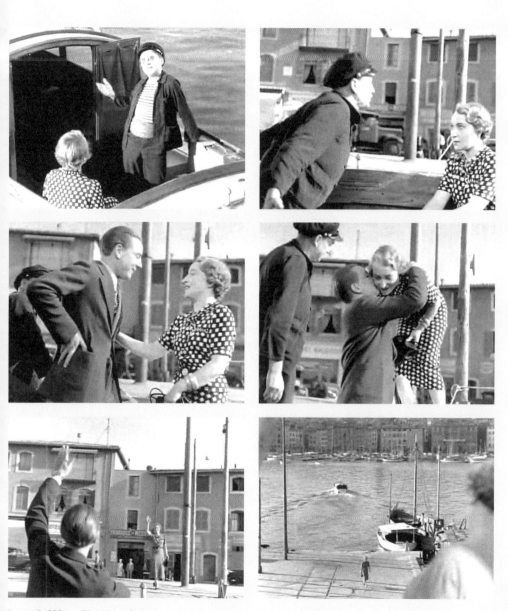

THE MARSEILLAISE/LA MARSEILLAISE (1938)

Château d'If, Embarcadère Frioul If, 1 Quai de la Fraternité

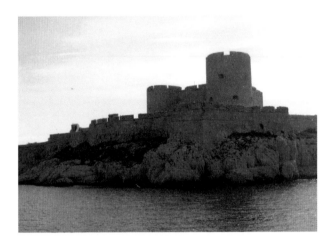

RELEASED DURING RENOIR'S creative peak, *The Marseillaise* is often overshadowed by his other masterpieces *La Grande Illusion/The Grand Illusion* (1937), *La Bête Humaine/The Human Beast* (1938) and *La Règle du jeu/The Rules of the Game* (1939). Unlike *Marie Antoinette* (W.S. Van Dyke), launched by the MGM the same year, and other Anglo-American films about the French revolution, *The Marseillaise* does not side with the aristocracy – unsurprising, given Renoir's Popular Front leanings. It is also a movie of its time: its characters stand up to tyranny, with which the film's contemporary audience could identify, as fascism was rapidly encroaching. The Château d'If (unforgettably featured in Dumas' *The Count of Monte Cristo*) stands in for Fort Saint-Nicolas, overtaken in 1790 by the people of Marseilles. Inspired by a rousing political meeting, Bomier (Edmond Ardisson) – their Trojan Horse – is snuck into the fort in a wine barrel. Renoir sought to avoid solemnity with this film, and its humour can be glimpsed in this scene. The small band seizes the fort without any bloodshed by falsely claiming there are thousands of revolutionaries outside (prison guard: 'Two thousand? Well in that case, let's surrender'). The aristocratic Saint-Laurent (Aimé Clariond), commander of Marseilles' forts, is truly baffled by the events, inquiring, 'the nation? Citizens? What is all that?' The key Marseilles characters sail by the Isle d'If later in the film, as Bomier mistakenly predicts that the popular hymn 'La Marseillaise' is a fad – when it actually became the national anthem, still proudly sung today. This film showcases the pride of the people of Marseilles and the city's involvement in the French Revolution. •**Zachary Ingle**

Photo © Gabriel Solomons

Directed by Jean Renoir
Scene description: Revolutionaries seize the fort and release the political prisoners
Timecode for scene: 0:21:01 – 0:29:44

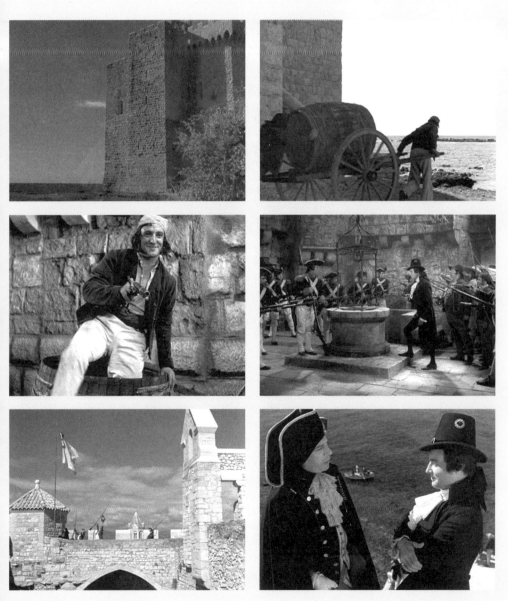

Images © 1938 Compagnie Jean Renoir, Socété d'Exploitation et de Productions Cinématographiques, Confédération Générale du Travail (CGT)

ODETTE/ODETTE, AGENT S.23 (1950)

Staircase of the Marseille-Saint-Charles Train Station, Square Narvik

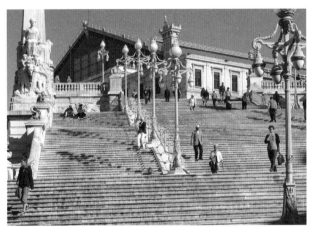

IN FILMING THE COURAGEOUS STORY of Odette Sansom (1912-1995) – the French-born woman based in England who volunteered to join the Special Operations Executive (SOE) and serve in occupied Europe during the Second World War – director Herbert Wilcox achieved a sense of authenticity by mounting several sequences in the European locations that the real Odette, played in the film by Anna Neagle, would have frequented. In this scene we see Odette arriving at Marseilles where she has been sent to retrieve the plans of the dockyards from under the noses of the Nazis. She descends the steps that lead down from the train station in the direction of Boulevard d'Athènes, stopping briefly amid the counterflow of people to gather her thoughts and guardedly assess her new surroundings, before continuing on towards her covert meeting at the harbour. Smartly dressed and attractive, Odette turns heads as she proceeds down the elegant staircase, but she retains her composure and succeeds in her attempts upon arrival to blend in with the people of the city. The 104 steps of the Escalier de la Gare Saint-Charles, inaugurated in 1925, were the work of renowned architects Eugene Sénès and Léon Arnal, and feature several ornate sculptures by Auguste Carli, Louis Botinelly, Auguste Martin and Henri Raybaud that represent the city's commercial, industrial and agricultural history. The staircase offers a commanding aspect of Marseilles for first-time visitors, but for Odette the view signals the prospect of the dangerous risks she is about to take.
➺ Jez Conolly

Photo left © Jean-Luc Lioult / right © Gabriel Solomons

Directed by Herbert Wilcox
Scene description: Odette arrives at Marseilles and descends the steps outside the train station
Timecode for scene: 0:20:18 – 0:20:34

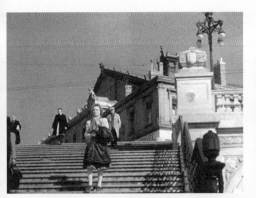
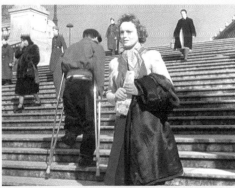

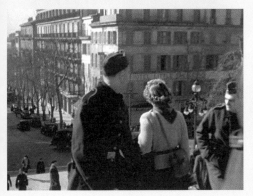
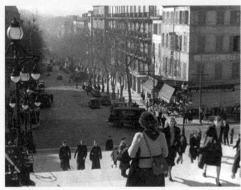

THE OLD PORT AND LA CANEBIÈRE

Text by
JEAN-LUC
LIOULT*

It's the beginning of a world. You come on board there, and you go straight ahead on La Canebière until Strasbourg, the Kehl Bridge, the Rhine, and the rest, until you stop wherever you want. It's always straight ahead. (*Seven Thunders*)

IF MARSEILLES HAS A HEART, it is the Old Port, the *calanque* (inlet) of Lacydon on whose banks the Phocaeans founded the city around 600BCE. Today, the Old Port is a narrow protrusion, an elongation of the sea into the city, protected by a promontory, oriented from east to west. Marseilles considers itself symbolically turned towards the south and the Orient. The Canebière prolongs this port-shelter on the same axis, barely rising from the Old Port.

The first films made by the Lumière brothers in Marseilles in 1896 show the Canebière's traffic, including horse-drawn wagons, carriages, pedestrians and harbour life: ships unloading, steamers leaving the port, fishmongers…the scene is set. *Cœur fidèle/True Heart* (Jean Epstein, 1923) draws dramatic effects from this atmosphere.

Pagnol's trilogy – *Marius* (Alexander Korda, 1931), *Fanny* (Marc Allégret, 1932), and *César*

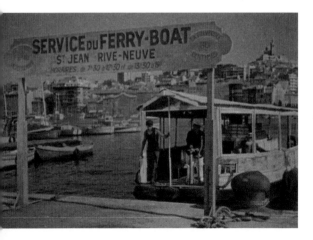

(Marcel Pagnol, 1936) – mythologizes the Old Port. This tale of young love threatened by the lure of the sea uses few shooting locations in Marseilles, although *Fanny* contains beautiful images of that era's Old Port.

Pagnol's trilogy was condensed into an English-language remake, *Port of Seven Seas* (James Whale, 1938), with Wallace Beery incarnating César, boss of the Bar de la Marine and Maureen O'Sullivan as Fanny (inexplicably renamed Madelon). Whale's Marseilles is 'a provincial city where every man knows his neighbour's business, and their principal interests are local politics, fishing – and fish stories!' The film's few exterior shots depict the city inaccurately.

Joshua Logan directed another remake, entitled *Fanny* (1961). Leslie Caron, unexpected choice for the heroine, incarnates her with freshness and vivacity. *Fanny* opens on a beautiful aerial view towards the Lacydon. The Old Port's real exteriors are very present, although frequently joined with interior shots filmed in the Boulogne-Billancourt studios near Paris. The Bar de la Marine is situated on Quai du Port adjacent to the Panier (not on Quai de la Rive Neuve, as in Pagnol). Some images offer fine glimpses seaward, including the legendary ferry boat: *Fanny* depicts the Fort Saint Jean–Rive Neuve route, which disappeared in 1974.

Consider the static use of a setting that operates like a background versus a dynamic conception that makes the configuration of locations a true motor driving the narrative. Returning to the 1930s, the Phocaean City is more visually complex in *Justin de Marseille* (Maurice Tourneur, 1935) than in Pagnol. This gangster story, inspired by real events, makes good – albeit stereotypical – use of locations: the film opens with tracking shots, along the quays, of a parade of singing children conducted by the 'Fada' (Raymond Aimos). Later, a cute linking scene shows Justin (Antonin Berval) being called to by fishmongers along the Quai du Port, again, using tracking shots. But studio images predominate.

The pre-war Old Port was dominated by the famous Transbordeur Bridge, erected in 1905 and filmed by László Moholy-Nagy in *Impressionen vom alten Marseiller Hafen/Impressions of the Old Marseilles Harbour* (1929), overlooking, with its elegant structure, the pass that opened seaward. A curious anonymous film, *L'insaisissable Monte-en-l'air* (ca. 1929), made the bridge the setting for a breathless chase. The Transbordeur appeared in the underappreciated *Seven Thunders* (Hugo Fregonese, 1957), which intensely evoked life on the Old Port under German Occupation. This film concludes with the January 1943 tragedy, when the Nazis, with the Vichy police, evacuated and bombed a section of this neighbourhood in order to 'cleanse' it. (The Transbordeur was destroyed in two phases: first in 1944 and then in 1945.)

The post-war ambiance of *Le port du désir/House on the Waterfront* (Edmond T. Gréville, 1955) evokes inevitable elements of Marseilles films, such as gangsterism, contraband and prostitution, yet the inspired direction has Hawksian dynamics. The relationship between the protagonists played by Jean Gabin and Andrée Debar, and intertwining actions at a ball (and also a restaurant, hotel and even brothel), L'Ancre de Marine, situated in the Vallon des Auffes, sometimes evokes *To Have and Have Not* (Howard Hawks, 1944). Above all, displacements and the balance of power converge, bringing together the Panier, Quai du Port and La Joliette. A murder scene along the railroad tracks parallel to the quays is treated in a series of tracking shots.

On the contrary, *Honoré de Marseille* (Maurice Régamey, 1956), although opening with beautiful views of the city shot from a boat entering the Old Port, is appalling, as it narrates the legend of Marseilles' foundation with the ridiculousness of a 'Series Z' film.

Three years later, the New Wave is, in some ways, born on the Old Port: Jean-Luc Godard's *À bout de souffle/Breathless* (1960) opens on the Quai des Belges. But Marseilles has its own cineastes. The short *Marseilles without Sun* (Paul Carpita, 1960) – fictitious, although conventional – offers documentary yet poetic images of the port.

In *Transit* (René Allio, 1991), adapted from Anna Seghers, the Old Port of 1940 forms the setting for the small, diverse group anxiously waiting after having fled Nazism: German resistors, Spanish republicans, European Jews, artists, intellectuals. Allio created two useful documentaries that go beyond stereotypes about Marseilles: *L'heure exquise/The Exquisite Hour* (1981) blends autobiography with reflections on the city's topography to produce a striking analysis, according to which the Canebière and the Old Port form the meeting point for peasants and sailors; next, Allio's *Marseille ou la vieille ville indigne/Marseilles or the Shameless Old City* (1993) revisits the city while giving the port and its maritime façade powerfully emotional vistas.

Popular French film-maker Henri Verneuil, an Armenian from Marseilles, made two autobiographical opuses about his youth in the Phocaean City at the end of his career: *Mayrig/Mother* (1991) followed by *588 rue Paradis* (1992). *Mother* shows his family's arrival with other immigrants in a scene recalling the Old Port of *Justin de Marseille*: Fort Saint-Jean, Notre-Dame de la Garde, the Jardin du Pharo, the Transbordeur Bridge. Yet, this set does not convey authenticity.

Robert Guédiguian, also of Armenian heritage, intends to be 'cinéaste of the neighbourhood': most of his films are set in l'Estaque. But in his darkest, *La ville est tranquille/The Town is Quiet* (2000), on a terrace overlooking the Old Port, bourgeois snobs of various political beliefs mingle. Here, a hired assassin executes one of them for unclear reasons. On this grating symbol concludes the cinematographic history of the Vieux-Port during the twentieth century. ✢

Translated by Marcelline Block

In Robert Guédiguian's, *La ville est tranquille/The Town is Quiet* (2000), on a terrace overlooking the Old Port, bourgeois snobs of various political beliefs mingle.

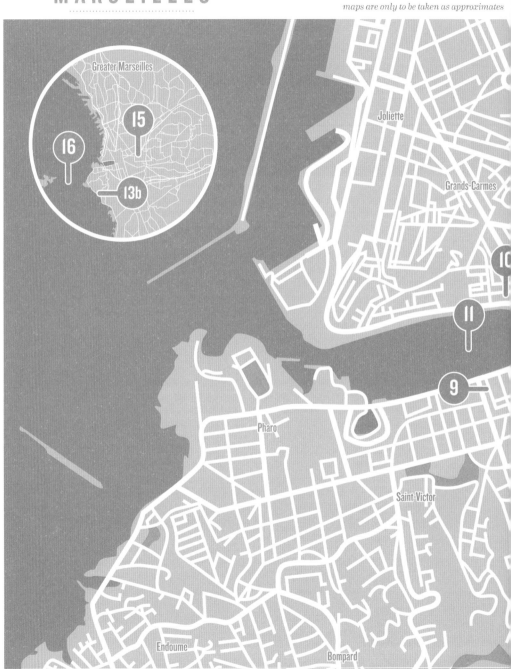

Greater Marseilles

15

16

13b

Joliette

Grands-Carmes

10

11

9

Pharo

Saint-Victor

Endoume

Bompard

MARSEILLES LOCATIONS
SCENES 9-16

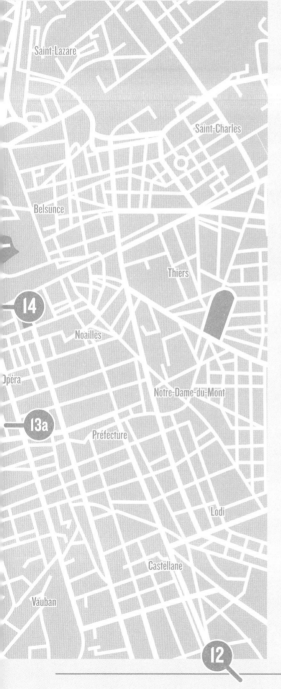

9.

MEETING ON THE DOCKS/
LE RENDEZ-VOUS DES QUAIS (1955)
Old port ferryboat: Vieux-Port between the
Hôtel-de-Ville and the Place des Huiles;
from the Vieux-Port to the Château d'If
page 32

10.

BREATHLESS/A BOUT DE SOUFFLE (1960)
Vieux-Port, 16 Quai du port
page 34

11.

FANNY (1961)
Notre-Dame de la Garde and Vieux-Port
page 36

12.

SECOND BREATH/
LE DEUXIÈME SOUFFLE (1966)
Coastal cliffs outside of Marseilles
page 38

13.

ARMY OF SHADOWS/
L'ARMÉE DES OMBRES (1969)
Palais de Justice de Marseille—
Pavillon Montyon, rue Emile Pollak;
Corniche Président John Fitzgerald Kennedy
page 40

14.

BORSALINO (1970)
Marseilles daily fish market
(Marché aux Poissons), Quai des Belges
page 42

15.

THE RED CIRCLE/
LE CERCLE ROUGE (1970)
Marseille-Blancarde (Gare de la Blancarde),
Place de la gare
page 44

16.

THE FRENCH CONNECTION (1971)
Château d'If, Embarcadère Frioul If,
1 Quai de la Fraternité
page 46

MEETING ON THE DOCKS/
LE RENDEZ-VOUS DES QUAIS (1955)

LOCATION *Old port ferryboat: Vieux-Port, between the Hôtel-de-Ville and the Place aux Huiles; from the Vieux-Port to the Château d'If*

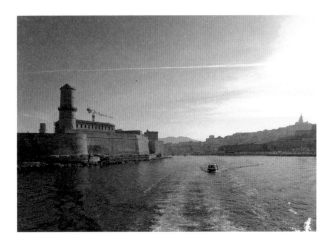

CARPITA (1922–2009), a left-wing schoolmaster, learned film-making himself. His *cinéma-vérité* recordings of the social movements of the 1940s and 50s were ahead of their time. His first feature, *Meeting on the Docks*, evokes Pagnol's trilogy through its depiction of the Marseillais dockers' and boatmen's simple lives, preceding Robert Guédiguian by filming the 1950 dockers' strike, a strike experienced as a festivity. The film was screened once in 1955, immediately seized and banned by the government, resurfacing to great acclaim in the 1980s. This sequence creates a sunny spell, as the dockers' discontent grows. The glowing young couple, Robert (André Maufré) and Marcelle (Jeanine Moretti) – whose name evokes 'Marseilles' – meet at the Vieux-Port, where Toine (Georges Pasquini) offers them a ride to the Chateau d'If. The next shots show different views of Marseilles. Toine proclaims it 'the greatest port in the world!' as the camera tracks from the Vieux-Port to the industrial harbour of La Joliette. Marseilles is seen from the sea, as the Château d'If looms up with its rocks and fortress, once a jail, as legendary as Alcatraz. As the boat stops, the couple rushes ashore, away from Toine's tour. They are framed in an isolated close-up, overlooking the castle. Sensual and innocent, the contrast between their matching dark hair and pristine white shirts emphasizes their beauty. 'C'est beau, Marseille!' exclaims Marcelle. Robert proposes marriage; their first kiss is framed against the sea and the coastline. Cut to the industrial docks, where Robert and his elder brother Jean, a union leader, work; yet another Marseilles, where they struggle against unemployment caused by the expensive Vietnam War. Robert will realize that happiness with Marcelle depends on solidarity with Marseilles and supporting the dockers' strike. **➦Georgiana M.M. Colvile**

Photo © Gabriel Solomons

Directed by Paul Carpita
Scene description: 'Marseilles is beautiful!' / 'C'est beau, Marseille!'
Timecode for scene: 0:05:21 – 0:08:40

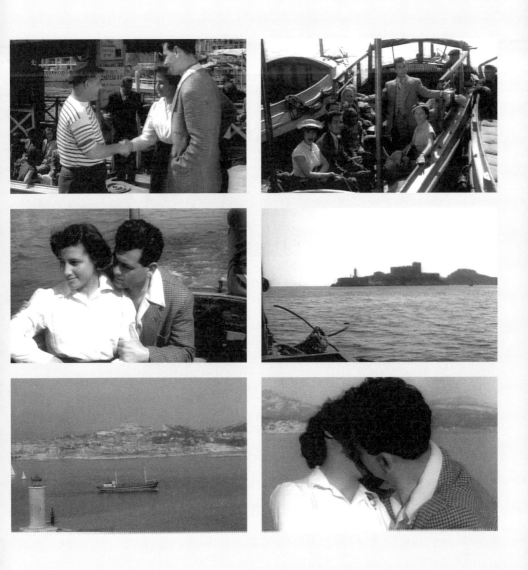

BREATHLESS/A BOUT DE SOUFFLE (1960)

Vieux-Port, 16 Quai du Port

WE BEGIN WITH A POINT-OF-VIEW SHOT, our eyes imitating those of the main character, Jean-Paul Belmondo's Michel Poiccard, in looking at a sexy lingerie advert in a newspaper. In a voice-over, Michel declares, 'After all, I'm an arsehole.' Even more than fifty years after it became one of the most influential films in cinema history, and brought the French New Wave international attention, *Breathless* still feels fresh and arresting. This is its opening scene, providing our first sight of Michel. He tells us so much about him by his body language: he is leaning against a shop; a cigarette, heavy with ash he is too lazy to tap off, dangles from his lips; the low brim of his hat almost obscures his eyes. He embodies insouciance. Suddenly, he steals a car. His accomplice, who no doubt thinks she is his girlfriend, pleads to come with him but he merely asks her the time and drives off. *Breathless* is one of the great Paris films – and in cinematic terms is synonymous with that city – but it begins in Marseilles, at the Old Port. The Old Port deserves its name: it was first used by the Phocaean settlers who founded Marseilles in 600 BCE, making the city the oldest in France. It still operates – despite the efforts of the Nazis who all but destroyed it in World War II – but the relatively shallow depths of its waters mean it is now principally a marina, rather than the large-scale port of earlier centuries. **Scott Jordan Harris**

Photos © Gabriel Solomons

Directed by Jean-Luc Godard
Scene description: Michel steals a car and flees Marseilles en route to Paris
Timecode for scene: 0:00:57 – 0:02 :07

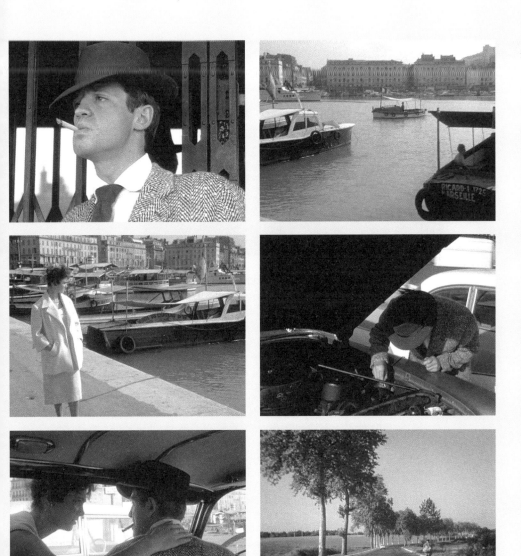

FANNY (1961)

Vieux-Port and Notre-Dame de la Garde

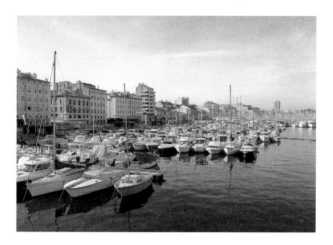

BASED ON THE EPONYMOUS 1954 Broadway hit, but eliminating the songs in favour of a romantic atmosphere of sensory place (shot on location by Jack Cardiff), Logan's condensation of Pagnol's famous French golden age trilogy centres upon teenaged sweethearts Fanny (Leslie Caron) and Marius (Horst Buchholz) as they negotiate competing desires (hers for a family, his for adventure) with bittersweet complications, until the joyful finale confirms the trailer's pronouncement – 'We of Marseilles have a great talent for enjoying life!' This early sequence condenses the vibrant energy of the port, the call of the sea, and Fanny's paradox: she must relinquish Marius to prove her love for him. The beaded curtain of César's bar is backdrop to Fanny's declaration of love; for Marius, it represents the drab confinement of work. The Vieux-Port, alive with the rhythms of fishmongering and commerce, shows Pierre encouraging Marius's maritime dreams, while Fanny follows him along the pier. Windswept and dazzled, Marius looks across the harbour, past the Château d'If, to the schooner 'Malaysia' ('La Malaisie'), a name suggesting exoticism, until all that is seen is the ship, representing Marius' dreams of imagined exploits. Above the Vieux-Port stands the majestic Notre-Dame de la Garde ('The Good Mother', or 'La Bonne Mère' to the locals), which dominates the view as it does Marseilles. It presides over the fates of this family, ensuring that everything will turn out well, as the vitality and humanity of the reinterpreted Pagnol narrative embraces its American audience to the lyrical swells of Harold Rome's score.
➻ Sandy Flitterman-Lewis

Directed by Joshua Logan
Scene description: Fanny longs for Marius; Marius longs for the sea
Timecode for scene: 0:22:47 – 0:22:23

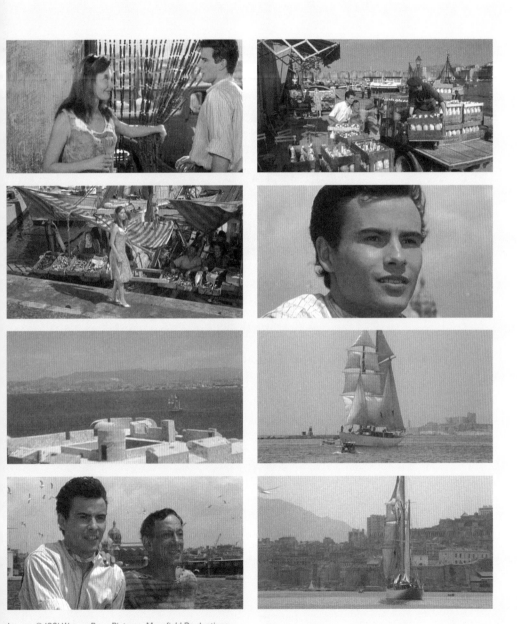

SECOND BREATH/LE DEUXIÈME SOUFFLE (1966)

The Route des Crêtes off of Marseilles (between La Ciotat and Cassis)

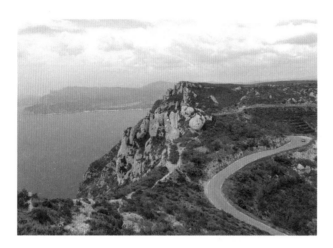

IF ONE WERE TO THINK of the most famous robbery in French cinema, one might consider the legendary thirty-minute silent heist in Jules Dassin's *Rififi* (1950). In *Second Breath*, however, Jean-Pierre Melville moves the heist from the hustle and bustle of the Parisian *bijouterie* to the windswept coastal cliffs of Provence near Marseilles. The landscape in which the robbery occurs is photographed by cinematographer Marcel Combes, who monochromatically captures the beauty of the wilderness in a way that is reminiscent of Cézanne's mature paintings of Mont Sainte-Victoire and its environs. Simultaneously, the landscape of Melville's heist echoes the sentiments of the film's epigraph: 'At birth, man is given a single right: the ability to choose his death. But if his choice is dictated by disgust for his life, then his existence would have been nothing but pure derision'. The sprawling landscape, wild and barren, creates a sense of topographical ennui, a feeling that permeates the film, and mirrors the malaise of ageing thief Gustave 'Gu' Minda (Lino Ventura), who in the end exercises his birthright to choose death, not from a distaste of life, but as a consequence of his vocation. ➻*Zachariah Rush*

Directed by Jean-Pierre Melville
Scene description: The Heist
Timecode for scene: 1:17:00 – 1:30:00

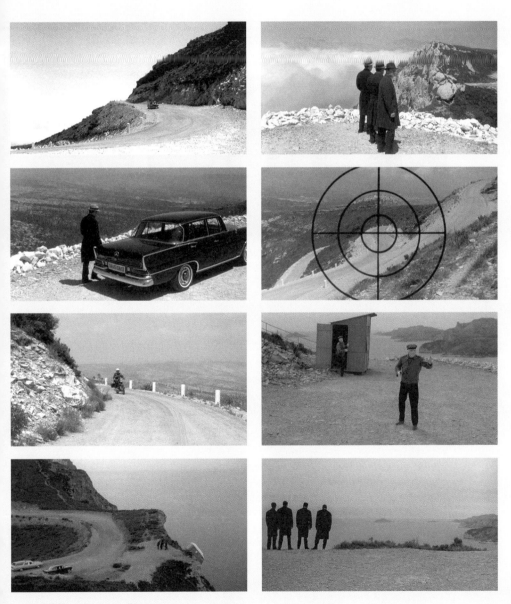

Images © 1966 Les Productions Montagne

ARMY OF SHADOWS/
L'ARMÉE DES OMBRES (1969)

LOCATION *Palais de Justice de Marseille—Pavillon Montyon, rue Emile Pollak;
Corniche du Président John Fitzgerald Kennedy*

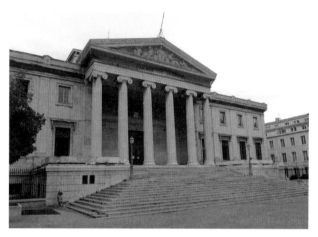

JEAN-PIERRE MELVILLE'S pessimistic French Resistance film, one of the
best, may also be his most personal, as he claimed to have been involved
in the Resistance. This was his third film set during the occupation of
France, following *Le silence de la mer/The Silence of the Sea* (1949) and *Léon
Morin, prêtre/ Léon Morin, Priest* (1961). Yet, *The Army of Shadows* has more
in common with the crime films for which Melville was primarily known,
and gangster parallels are evident throughout, most especially in this scene
and its brutal aftermath. After Philippe Gerbier (Lino Ventura) escapes
and has a quick shave at a barber's shop, the scene shifts to Paul Dounat
(Alain Libolt) in Marseilles, as he waits by the Palais de justice. After a few
minutes in the mid-afternoon sun, he is picked up by Felix (Paul Crauchet)
and 'Le Bison' (Christian Barbier), Gerbier's fellow *résistants*. The traitor Paul
is forced into the car (note the large gas cylinders on top of the car, which
initially look like artillery, but, in fact, are indicative of the fuel shortage).
For his traitorous activities, the young Dounat is tied to a chair (a recurring
iconographic leitmotif in the film) and strangled to death. This execution
foreshadows the film's shocking final scene in Paris, when the *résistants* make
the agonizing decision to kill a member of their own network – the woman
who had saved many of their lives but, due to a personal conflict, had become
a Nazi informant. Cool colours dominate the *mise-en-scène* in most of the
film, giving it a dark, monochromatic look, but the execution of Paul is one
of the few instances when the sun shines, contrasting sunny Marseilles with
tempestuous Paris and Lyon. ⇥*Zachary Ingle*

Directed by Jean-Pierre Melville
Scene description: Rendez-vous with a traitor/Good-bye to a traitor
Timecode for scene: 0:29:44 – 0:30:56

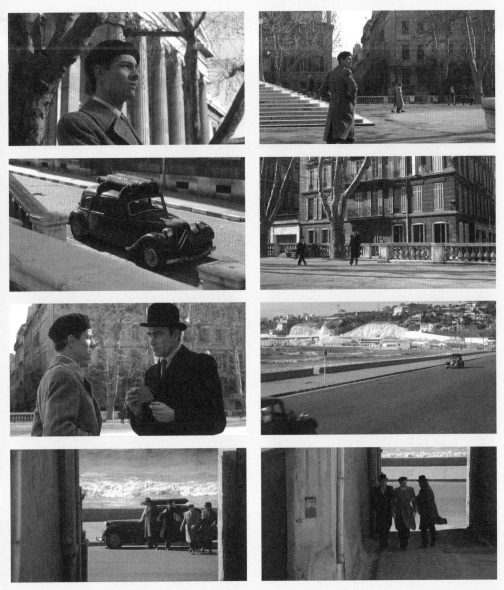

BORSALINO (1970)

Marseilles daily fish market (Marché aux Poissons), Quai des Belges

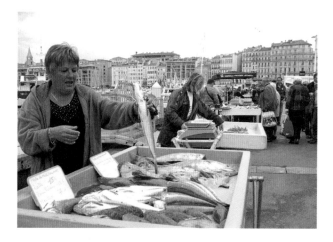

IT IS 1930S MARSEILLES. Roch Siffredi (Alain Delon) – a dapper, small-time gangster fresh out of prison – is looking for his moll, Lola (Catherine Rouvel). When he finds her with the confident François Capella (Jean-Paul Belmondo), Siffredi confronts Capella. Neither wins the fight, so they become fast – and best – friends. They go into illegal business together, with their first big job to eliminate the Pradel brothers, who are Madame Escarguel's competition in the fish business. Siffredi and Capella head to Marseilles' historic fish market on the Quai des Belges and perpetrate a three-step scheme involving rotten fish, accomplices who complain about said fish's bad quality, and stray cats wreaking havoc everywhere. The resulting chaos by the Old Port wipes out the Pradel brothers. As a film, *Borsalino* has incredible energy and charm. The ragtime score, the evocative locations, and the period details recreate a moment in Marseilles' history with great panache. During one scene, a crime leader describes Marseilles with pride as 'more modern and prosperous every day.' The same can also be said of Siffredi and Capella. Each mobster they eliminate results in a better and more stylish lifestyle for the duo: fancier suits, nicer digs and more expensive cars. Delon is impeccable as the unsatisfied and increasingly sophisticated Siffredi; Belmondo is unflappable as the fun-loving and savvy, yet ultimately tragic figure of Capella. At the heart of the film is the story of their friendship and partnership and, more than other any crime caper, this is what we most want to succeed. ➟**Kristiina Hackel**

Photo © Melissa Leu

Directed by Jacques Deray

Scene description: 'This fish isn't fresh!': Capella and Siffredi sabotage the Pradel Brothers

Timecode for scene: 0:40:22 – 0:42:35

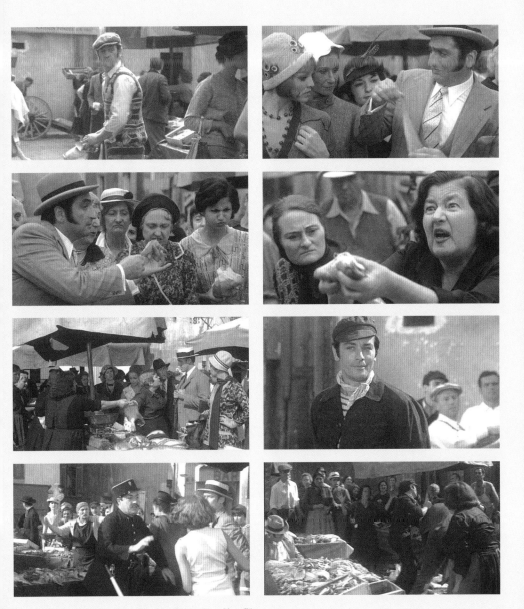

THE RED CIRCLE/LE CERCLE ROUGE (1970)

Gare de Marseille-Blancarde, Place de la gare

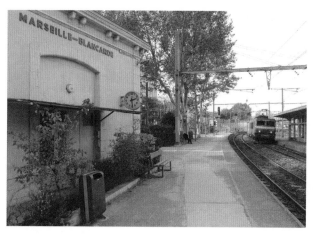

JEAN-PIERRE MELVILLE'S *The Red Circle* opens with an apocryphal epigraph attributed to Buddha (which was in fact invented by Melville). The premise is that men fated to meet must inevitably do so, either consciously or not: 'invariably, they will be reunited within the red circle', according to the pseudo-Buddha. The first of these two men is Vogel (Gian-Maria Volonté), a brutal, psychopathic murderer. The second is Corey (Alain Delon), a suave gentlemanly thief recently released from prison. The opening scene takes place at the Gare de Marseille-Blancarde. The car carrying Vogel and his custodian, Commissar Mattei (Bourvil), races to the train station – narrowly avoiding a collision – before screeching to a halt outside the passenger building just as the train arrives. The scene is very short, but like the proverbial mustard grain, it contains the essence of something larger than itself. Here, at Marseille-Blancarde, is where Vogel's escape from Mattei is set up, and the mythological Clotho spins her imperceptible thread predestining the partnership of Vogel and Corey. The Gare de Marseille-Blancarde, whose rhythmic cycles of arrivals and departures, and whose tracks with unswerving tyranny determine the destination of all aboard, serves as an apt opening metaphor for the diegetic fatality Melville is pursuing.
⟿Zachariah Rush

Photos © Gabriel Solomons

Directed by Jean-Pierre Melville
Scene description: Vogel is escorted to the train station
Timecode for scene: 0:00:00 – 0:05:00

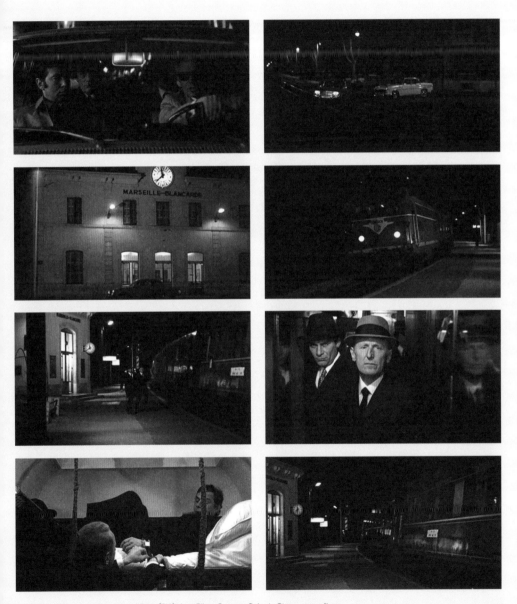

THE FRENCH CONNECTION (1971)

LOCATION *Château d'If, Embarcadère Frioul If, 1 Quai de la Fraternité*

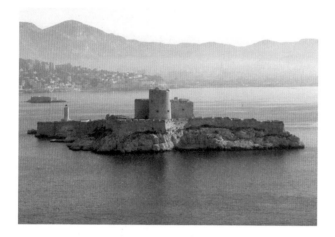

BUILT ON IF ISLAND OFF Marseilles' coast between 1524 and 1531, the Château d'If – first a fortress, then a prison until the late 1800s – is often featured in history books, fiction, and film such as *La Marseillaise* (Jean Renoir, 1938). Dumas' novel *The Count of Monte Cristo* (1844), narrates how Edmond Dantès, accused of treason, remained there for 14 years before escaping. *The French Connection*, winning Oscars for Best Actor, Picture, and Director – adapted from Robin Moore's book (1969) – is based on true events in 1961. In the film, plans to smuggle 112 pounds of heroin from Marseilles to New York are finalized on the Château d'If's grounds. Here, dapper drug lord Charnier (Fernando Rey) and acolyte Nicoli (the inimitable Marcel Bozzuffi) meet their mule, Henri Deveraux (Frédéric de Pasquale), onscreen surrogate for Jacques Angelvin (1914–78), the Marseilles-born TV anchor/personality and co-host of the popular program *Télé-Paris* (later called *Paris-Club*). Nicoli distrusts Deveraux, but Charnier calls him an 'inspired' choice: his celebrity status would allow him to 'travel freely', eluding scrutiny. Charnier chides Nicoli, 'Maybe he'll put you on television'. The three men conclude their criminal pact under the gaze of Notre-Dame de la Garde ('The Good Mother'), across the bay. The Château d'If's construction as a prison foreshadows Deveraux's fate in the film: in reality, Angelvin was arrested, served four years in US prison, and died in France ten years after his release. Although Charnier escapes Detective 'Popeye' Doyle (Oscar-winner Gene Hackman), they will have another showdown in *The French Connection II* (John Frankenheimer, 1975) – a fictitious sequel – in which Popeye arrives in Marseilles to hunt him down. **Marcelline Block**

Photo © Gabriel Solomons

Directed by William Friedkin

Scene description: Charnier and Nicoli meet TV star Deveraux, their new partner in crime

Timecode for scene: 0:20:10 – 0:22:25

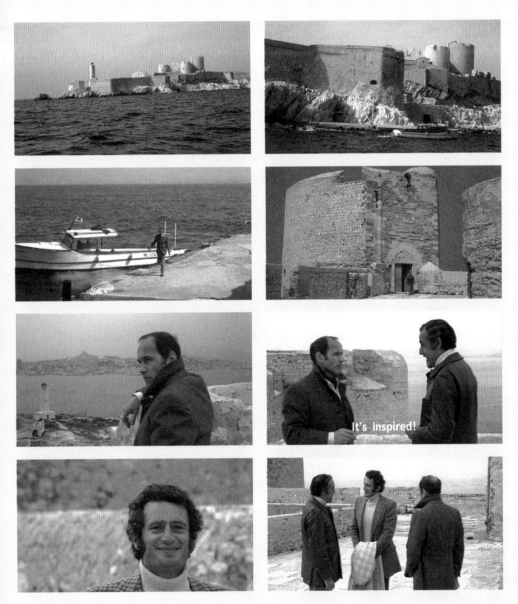

It's inspired!

'THE UNDERWORLD IS IN HIS LANDS'*

Text by
OLIVIER
BOHLER*

Marseilles Gangster Films

THE MARSEILLES GANGSTER FILM has a lengthy history, starting with *Justin de Marseille* (Maurice Tourneur, 1935). Paris-born Tourneur had a brilliant US career; this film bursts with American references. It begins with a Marseilles resident declaring to a journalist, 'what all of you are seeking here is Chicago: blood, voluptuousness, death.' He was right: the article was entitled, 'Is France's second city jealous of Chicago's bloody laurels?' But there is also a comedic aspect: if hoodlums cite *Scarface* (Howard Hawks, 1931), it is to make fun of a scaredy cat who barricades himself at home after a shootout. However, Tourneur sought a certain truth about Marseilles, and he knew to associate with the right people: screenwriter Carlo Rim from Nîmes (who requested permission to write the film from Paul Carbone, boss of the Marseilles underworld!); Marseillais songwriter Vincent Scotto; Antonin Berval as Justin, who debuted at the Alcazar, the famous Marseilles music hall; Milly Mathis, Paul Ollivier and Tino Rossi rounded out this meridional cast.

It is thought that Tourneur and Rim were inspired by journalist Albert Londres' book, *Marseille, Porte du Sud* (1927), which gives the film the figure of the journalist, provides invaluable testimony about the city and lends *Justin* its surprising modernity. Londres appears fascinated by cohorts of men from all over the world who pass through the port. Similarly, Tourneur's film shows eastern merchants, Chinese masters of opium trafficking, Africans, sailors, passers-by, street dancers, assassins – one dressed as an American – not to mention Justin's rival, Italian-speaking gang, led by Esposito (Alexandre Rignault). In the 1930s context, *Justin*'s realism is unthinkable in Hollywood. Justin/Tourneur explains that men are like sea urchins: all different, yet worthy of respect.

Among these characters, one known as 'The Chinese' – the true mandarin of opium trafficking – seems issued from an American noir, since Marseilles never had a substantial Asian community. Yet, Londres claims, 'There is a generalissimo of the opium smugglers. His name is unknown, but he is called the Father […] he is Chinese [and] possibly the most mysterious man in Marseilles' (1995: 107). Londres describes the interrogation of a passenger debarking a ship with two loaves of opium-filled bread, before recalling:

[W]e remember a recent time when each drug courier brought with him a quadriplegic; customs officials stood aside to let opium, hidden inside crutches, go through. There was also the stretcher! The poor shivering colonial lying down on it, a blanket covering him to the chin, his pockets crammed with drugs [...]. (1995: 107)

Justin's first scene condenses these elements: 'The Chinese', seeking his drug shipment at the boat,

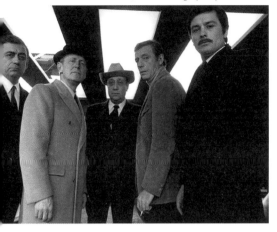

only to see it elude him when Esposito's men throw themselves on wheelchair- and stretcher-bound passengers, ripping their opium-filled pillows and mattresses. The police only manage to question two shipmates carrying opium-stuffed bread. But in a port, there are as many men as there are criminals: like Londres, Tourneur evokes pimps, pickpockets, assassins, owners of gambling houses...only Justin's real activities remain unknown.

Moving forward a few years, past *Pépé le Moko* (Julien Duvivier, 1937), which witnesses Jean Gabin, in the titular role, dying in front of a Marseilles-bound ship; *Inspector Sergil* (Jacques Daroy, 1947); *Le port du désir/House on the Waterfront* (Edmond T. Gréville, 1954), and *Mémoires d'un flic/Memories of a Cop* (Pierre Foucaud & André Hunebelle, 1956). It is now 1959. Facing the Vieux-Port, Michel Poiccard (Jean-Paul Belmondo), with his accomplice, a brunette, steals a car. Inside is a revolver, with which he will kill a policeman, sealing his destiny. In what other French city would an anonymous driver casually leave a weapon in his car? If Godard's film began in Paris, no one would have believed it. Unless this is a tribute to an arms trafficker, who, four years before the invention of cinema, died in Marseilles, *breathless* – namely, Arthur Rimbaud.

Next, three Jean-Pierre Melville films: *Le deuxième souffle/Second Breath* (1966), *L'armée des ombres/Army of Shadows* (1969), *Le cercle rouge/*

It is thought that Tourneur and Rim were inspired by journalist Albert Londres' book, Marseille, Porte du Sud (1927), which gives the film the figure of

The Red Circle (1970). Originally from north-eastern France, Melville had relatives in Marseilles, where he participated in the Resistance before leaving, returning to Provence with the American troops (1944), during which he probably associated with the local milieu. In *Second Breath*, after escaping from prison, 'Gu' Minda (Lino Ventura) comes to Marseilles to prepare the attack on a platinum-filled armoured car. He seems to go back in time: for their heist, on the Route des Crêtes, the gangsters wear the same black masks as in Louis Feuillade's silent films. When Gu is kidnapped by what he thinks is a rival gang (but are policemen), they have powdered, made-up faces, as in the 1920s. Ditto in *Army of Shadows*, set in 1942: fake policemen (Resistance members) nab a collaborator to assassinate him near the Corniche. Car, hats, silence, seascape and Ventura link these scenes. From one film to another, there is no lapse in time – for Melville, World War II is omnipresent. On the contrary, *The Red Circle* offers an Americanized vision of the city, with the Canebière akin to a New York City avenue that Corey (Alain Delon) traverses the morning after his release from prison. Miraculously, he buys an American car there, before starting, alone, a game of billiards in the pool hall at 26 Rue Pavillon – leaving behind two corpses before fleeing on the new Aix-en-Provence motorway.

Despite *Borsalino* (Jacques Deray, 1970), the 1970s are American years. If *The French Connection* (William Friedkin, 1971) has only a few scenes in Marseilles, its sequel (John Frankenheimer, 1975) allows us to finally discover the ethnically diverse city described by Tourneur, although imbued with a dark, absolute realism. The underappreciated *Marseille contrat/The Marseille Contract* (Robert Parrish, 1974) reunites Anthony Quinn and Michael Caine, linking Marseilles to the entire Côte d'Azur, blending luxury, corruption, poverty. Drugs are delivered by helicopter to the Vieille Charité, which was in ruins; today, it is one of Marseilles' most beautiful museums.

Retour à Marseille/Return to Marseilles (René Allio, 1980) is the first film depicting delinquency in social terms, a torch passed to Robert Guédiguian, who holds it high today. But that becomes another story entirely, of everyday Marseillais...

Nota Bene: never forget the great, prodigious actor of Italian heritage, Marcel Bozzuffi (1928–88). Whether in Melville, Parrish or Friedkin, he is *the* quintessential Marseilles bad guy. ✛

**Translated by Marcelline Block*

LOCATIONS MAP

MARSEILLES

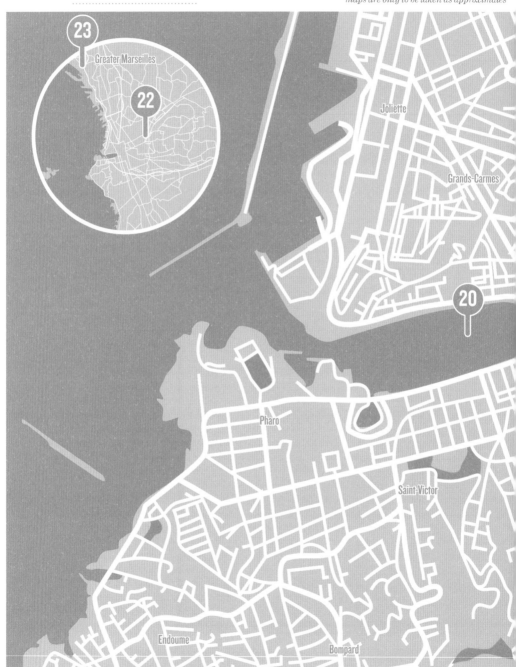

23

Greater Marseilles

22

Joliette

Grands-Carmes

20

Pharo

Saint-Victor

Endoume

Bompard

MARSEILLES LOCATIONS
SCENES 17-24

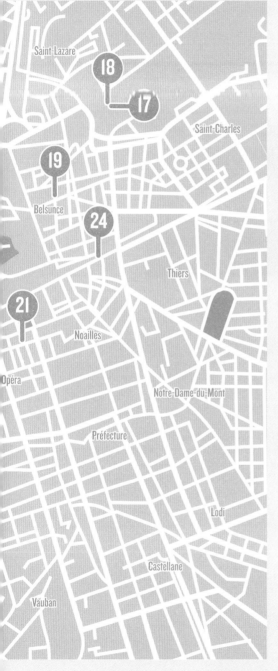

17.
BORSALINO AND CO. (1974)
Marseille-Saint-Charles Train Station,
Square Narvik
page 52

18.
THE MARSEILLE CONTRACT/
MARSEILLE CONTRAT (1974)
Stairway of the Marseille-Saint-Charles
Train Station, Square Narvik
page 54

19.
THE FRENCH CONNECTION II (1975)
Cours Belsunce, Rue Colbert,
Rue du Baignoir
page 56

20.
THE GYPSY/LE GITAN (1975)
Vieux-Port with Notre-Dame de la Garde
in the distance
page 58

21.
THREE SEATS FOR THE 26TH/
TROIS PLACES POUR LE 26 (1988)
Opéra Municipal de Marseille, 2 Rue Molière
page 60

22.
ROSELYNE AND THE LIONS/
ROSELYNE ET LES LIONS (1989)
Ancien Zoo de Marseille,
Boulevard du jardin zoologique
page 62

23.
1,2,3, SUN/UN, DEUX, TROIS, SOLEIL (1993)
Saint-André
page 64

24.
BYE-BYE (1995)
La Canebière
page 66

BORSALINO AND CO. (1974)

Marseille-Saint-Charles Train Station, Square Narvik

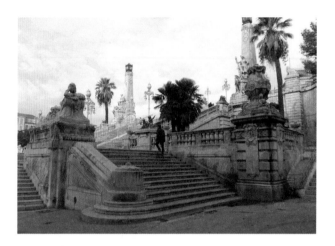

JACQUES DERAY'S *Borsalino and Co.* is a 'gun opera'/star vehicle for its leading actor and producer Alain Delon, who reprises the role of Roch Siffredi, a taciturn crime boss who has inherited power from his murdered partner, Capella (Jean-Paul Belmondo). Siffredi seeks vengeance for Capella's death from Francesco and Giovanni Volpone. Siffredi and the Volpones vie for control of the underworld of Marseilles, shot in its all its historic texture by cinematographer Jean-Jacques Tarbes. Early in the film, Siffredi discovers that Francesco Volpone, responsible for the murder of Capella, is on a train headed for the Saint-Charles train station in Marseilles. Siffredi and three of his men enter this train at the Montelimar Station to confront the complacent Francesco in his private car. Siffredi speaks to the frightened Francesco briefly before ordering two of his men to throw Francesco to his death from the speeding train. The scene suddenly shifts to morning, when the train arrives at Gare Saint-Charles. Siffredi and his men detrain amidst great plumes of steam, only to encounter Francesco's brother Giovanni, who asks Siffredi if they had seen his brother, as he does not know what happened to Francesco. Siffredi responds vaguely and then he and his men quickly exit the station. Once in his car, Siffredi turns to his right-hand man and says, 'Yes, Fernand. It's war'. For the next hour of screen time, Siffredi's life is under constant threat as Giovanni Volpone revenges his brother's assassination. ↝*Lance Lubelski*

Photo © Gabriel Solomons

Directed by Jacques Deray
Scene description: 'It's War'
Timecode for scene: 0:12:22 – 0:14:56

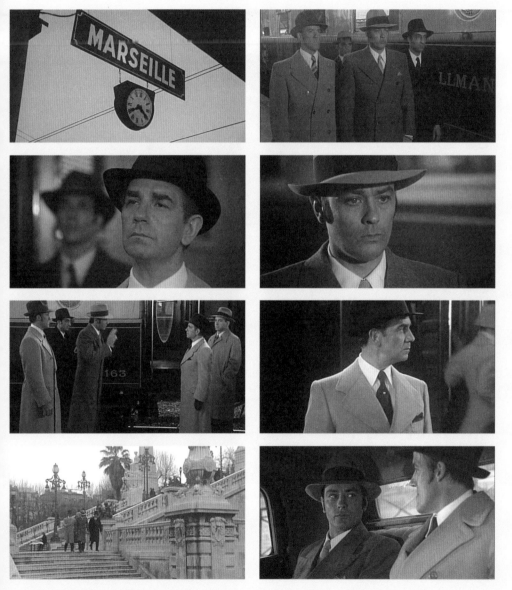

THE MARSEILLE CONTRACT/ MARSEILLE CONTRAT (1974)

Stairway of the Marseille-Saint-Charles Train Station, Square Narvik

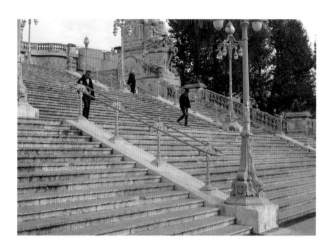

IN *THE MARSEILLE CONTRACT* (also known as *The Destructors*), Steve Ventura (Anthony Quinn), the senior officer for the Drug Enforcement Agency at the US embassy in Paris, has a problem. The last two agents he has sent down to Marseilles to deal with the rich and well-connected drug dealer Jacques Brizard (James Mason), have been killed. So Ventura comes up with an unorthodox solution to deal with the Brizard problem: he hires a hitman, John Deray (Michael Caine), to kill him. Deray heads south to Marseilles to take out Brizard, and we enter a world of calliope car chases, yacht club lunches and contract killing that Caine navigates with ease and aplomb. In one of the most dynamic scenes of the film, Deray successfully evades two men waiting for him inside the Saint-Charles train station – but another henchman emerges from a car outside. Deray slams the door on him, grabs a motorcycle and then rides it down the steep, historic steps like a 1970s James Dean. Deray speeds by the sculptures of ships, grains, and colonies – stone and bronze tributes to Marseilles' history of trade, but a bit ironic given the type of trade dramatized in the film. **Kristiina Hackel**

Directed by Robert Parrish
Scene description: Escape by motorcycle
Timecode for scene: 1:09:38 – 1:10:22

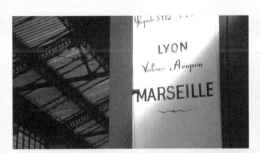
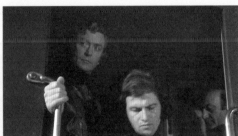
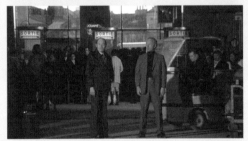
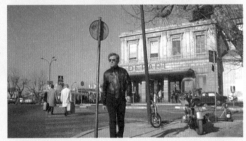
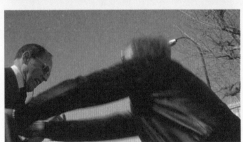
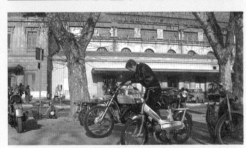
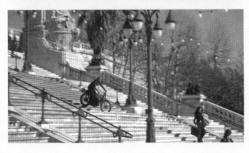
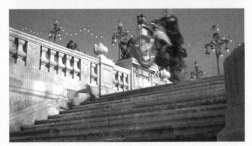

Images © 1974 Kettledrum Films, PECF

THE FRENCH CONNECTION II (1975)

LOCATION *Cours Belsunce, Rue Colbert, Rue du Baignoir*

IN *THE FRENCH CONNECTION II*, Detective 'Popeye' Doyle (Gene Hackman) again confronts his nemesis, drug lord Charnier (Fernando Rey), now on Charnier's turf, Marseilles. Unlike *The French Connection* (Friedkin, 1971), this sequel is fictitious, yet recuperates Doyle's intensity in his obsessive pursuit. The film's penultimate chase depicts the Marseilles police following Charnier's right-hand thug, who dodges them along crowded streets. The culprit is spied on Cours Belsunce before turning into a side street in the Belsunce neighborhood, which police chief Barthélémy (Bernard Fresson) calls 'the Arab Quarter' – emphasized by extradiegetic Middle Eastern music. As Charnier's man purchases a kebab on Rue du Baignoir, an undercover cop tails him. The police team then charges down the ancient street into Charnier's drug factory, where heroin is hidden within cans labelled bouillabaisse. Assimilating drugs with the famous speciality fish soup renders them both exportable Marseilles products. The 'Arab Quarter' setting shows how, in Marseilles, some traditionally immigrant neighborhoods are centrally located. Belsunce, one of Marseilles' oldest *quartiers*, is located in the city's first arrondissement – out of 16. Traditionally, in French cities, newcomers, particularly those arriving from former colonies, are often relegated to government housing projects (HLMs) in a separate zone away from the city centre (such as the Paris of Mathieu Kassovitz's *La Haine/Hatred* [1995], or the Quartiers nord of Marseilles in Bertrand Blier's *Un, deux, trois, soleil/1, 2, 3, Sun* [1993] and Robert Guédiguian's *L'Argent fait le bonheur/Money Makes Happiness* [1993]). This scene recalls Marseilles' ethnic diversity: as a port, it has been the destination of innumerable immigrants. **↝*Marcelline Block***

Photo © Jean-Luc Lioult

Directed by John Frankenheimer
Scene description: 'He goes to the Arab Quarter!'
Timecode for scene: 1:46:23 – 1:51:04

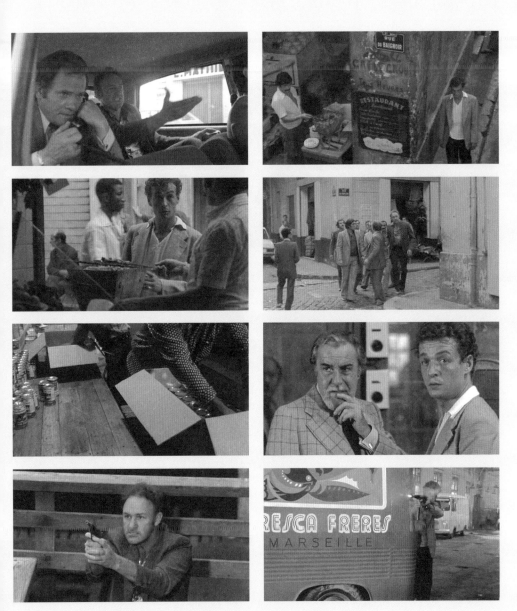

THE GYPSY/LE GITAN (1975)

Vieux-Port with Notre-Dame de la Garde in the distance

KNOWN FOR HIS BROODING CHARACTERS and handsome face, Alain Delon was hailed as the French James Dean. But in *The Gypsy*, about a renegade and outlaw, he is more like Clint Eastwood's hardened 'Man with No Name'. Delon incarnates Hugo Sennart – 'the Gypsy' – a kindred outsider, fierce but detached, with squinted eyes and a deadly stare. He steals from the state to support his nomadic tribe, and murders his enemies without pity. He was last incarcerated for assassinating a French mayor who expelled his clan. Yet he lives by a code of honour and is seen by his own people as an avenging angel. 'I'm no murderer,' he tells a police inspector at gunpoint. The European Roma have long suffered from persecution and prejudice. They are 'despised', according to one character, and called 'vermin' by another. The Sennart clan travel in caravans and live outdoors, but the police drive them out wherever they go. When asked why, Hugo responds: 'They want our blood, race, culture, and customs to disappear.' In this scene, Sennart and his cohorts sit in a Marseilles waterfront café with plans to assassinate the Rinaldi brothers, nightclub owners and police informants. One accomplice is first sent across the way, with neo-Byzantine basilica of Notre-Dame de la Garde looming in the distance. The Gypsy makes his entrance soon after: it's payback time. ' You never see a Gypsy help a cop,' he says calmly. Then he kills them.
⊷ Tina Wasserman

Directed by José Giovanni
Scene description: The Gypsy and his outlaw team confront informant bar owners in Marseilles
Timecode for scene: 0:44:53 – 0:49:15

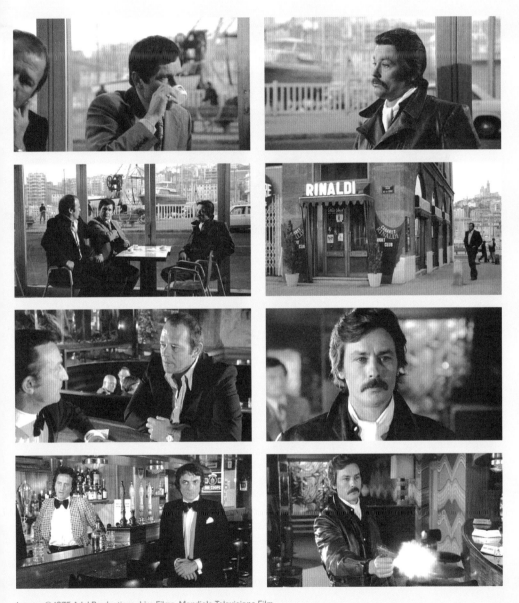

THREE SEATS FOR THE 26TH/
TROIS PLACES POUR LE 26 (1988)

LOCATION *Grand Hotel Beauveau Marseille, 4 Rue Beauveau*

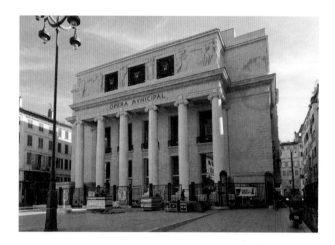

'TIENS, LE-VOILÀ' ('There it is'): the camera cuts from a close-up of Yves Montand to a long shot of the Opéra Municipal de Marseille's nearby façade. In *Three Places for the 26th*, Montand returns to the city of his youth to star in an autobiographical musical show, yet the real leading actor of the film is the theatre itself. Celebrating the Montand myth, this film is also a self-reflexive tribute to Jacques Demy's universe – as it is the great French film-maker's final film – and as such, is filled with classic elements of a Demy musical: singing, dancing sailors, the magic of chance, and love. Theatre is the largest of the Montand/Demy nesting boxes, the one that contains everything else. A unique combination of Parisian style and southern liveliness, the cultivation of Montand's persona owes much to the Midi (the south of France). The shady but vital Marseilles of the 1930s is the place of his lost, highly idealized youth – a place, however, more alive in memory than in reality. Even the city's well-known Old Port, depicted as little more than a tourist resort in a later scene of the film, is a fabulous site bursting with life when recreated within the theatre's walls – where most of the film takes place. All Marseilles, and all that it represents, is swallowed up inside its main theatre, as it is in Montand's mind. Perhaps not for Montand, but for Montand and Demy (who together function truly as one unit in this film) life itself is certainly, at its best, theatre. ↦ *Marco Grosoli*

Directed by Jacques Demy
Scene description: A city of lost memories and its Opéra Municipal
Timecode for scene: 0:08:18 – 0:13:10

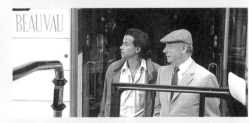
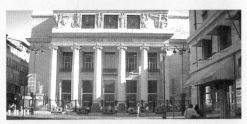
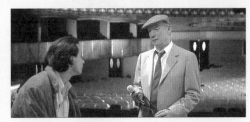

ROSELYNE AND THE LIONS/
ROSELYNE ET LES LIONS (1989)

Ancien Zoo de Marseille, Boulevard du jardin zoologique

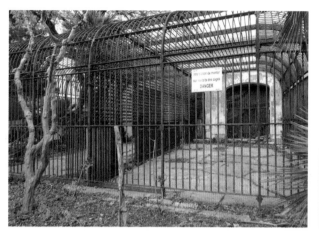

ALTHOUGH BEST KNOWN FOR *Diva* (1981), one of the first films of the 1980s *cinéma du look*, Jean-Jacques Beineix has always been drawn to vibrant colours. He often chose to shoot on-location in Marseilles, where he took advantage of the sun-saturated beaches and rich blue hues that this Mediterranean backdrop offers. (however, he filmed, in Cinecittà studios, a dark version of the city, which is anything but sundrenched, for his *La lune dans le caniveau/The Moon in the Gutter*, 1983). While a number of other cities are shown in *Roselyne and the Lions*, especially Munich, where the protagonists find fame as the star act in Koenig's circus, the city of Marseilles is where it all begins for Thierry (Gérard Sandoz) and Roselyne (Isabelle Pasco). More specifically, Beineix shot these scenes at the Centre de Dressage de Fauves and the École de Dompteurs du zoo de Marseille. Suspended from school for a prank, Thierry stumbles upon the zoo where he meets Roselyne, a lion-tamer apprentice to Monsieur Frazier (Gabrielle Monnet). Taken with Roselyne but also enchanted by the lions, he volunteers to work for Frazier in exchange for taming lessons. After failing his *baccalauréat*, Thierry and Roselyne run away to pursue their dreams of working professionally with these magnificent animals. In this scene, the lions' arrival is quite an event for the local denizens, an occasion marked by Carole Fredericks' stirring rendition of Beineix's (and Reinhardt Wagner's) adaptation of Verdi's *Aida*. Frederick's performance here as 'the golden voice' evokes that of Wilhelmina Fernandez in *Diva*; however, in these images we see a different type of homage, both to Frederick's African heritage, and especially to the lions themselves. These two majestic imports to this port city add to its multi-ethnic richness. •◦ *Adrienne Angelo*

Photos © Gabriel Solomons

Directed by Jean-Jacques Beineix
Scene description: Thierry's first visit to the lion show in the Marseilles zoo
Timecode for scene: 0:07:44 – 0:14:33

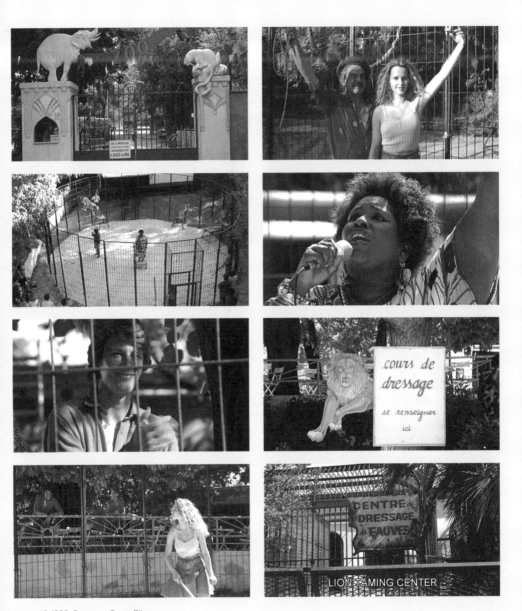

1,2,3, SUN/UN, DEUX, TROIS, SOLEIL (1993)

Saint-André

BERTRAND BLIER'S SURREAL, absurdist *1, 2, 3, Sun* juxtaposes the overcrowded, cramped environs of Marseilles' *cités* (suburban housing developments) with denuded, sun-drenched expanses between the urban centre and the port that looks out on the Mediterranean. The locales and cinematography provide fixed points of reference in a film that eschews linear narrative. Indeed, the vivid brightness of the film's exteriors forces the viewer to scrutinize the plot, and to seek signs of lucidity within the chaos of shifting storylines and points of view. The contrast between visual clarity and narrative disorientation is evoked when heroine Victorine (Anouk Grinberg) sees Rafik (Stéphane Slima), clad in black, splayed out on white, sun-soaked rocks, along a dusty path leading from the massive white apartment blocks to the sea. As Victorine approaches, her vulnerability and fragility find a visual mirror in the large hills and buildings towering behind her. Her yellow top and red shorts both recall the heat of the landscape and point to her emotional immaturity. When Rafik calls out to her, she is framed in front of an old abandoned car, while he is set against the highway below. When she draws close to him so he can touch her body, the two are placed before the shimmering port with its huge ships and cranes, heightening the absurdity of the scene, as well as the comparative insignificance of these two figures vis-à-vis the commercial landscape. The bustling port helps to articulate the ways in which these characters are stuck without prospects in an impersonal urban space. ➥*Lance Lubelski*

Plan D'Aou / Photo © Hélène Bossy

Directed by Bertrand Blier
Scene description: 'Bonjour, Victorine': Victorine encounters Rafik
Timecode for scene: 0:25:27 – 0:27:39

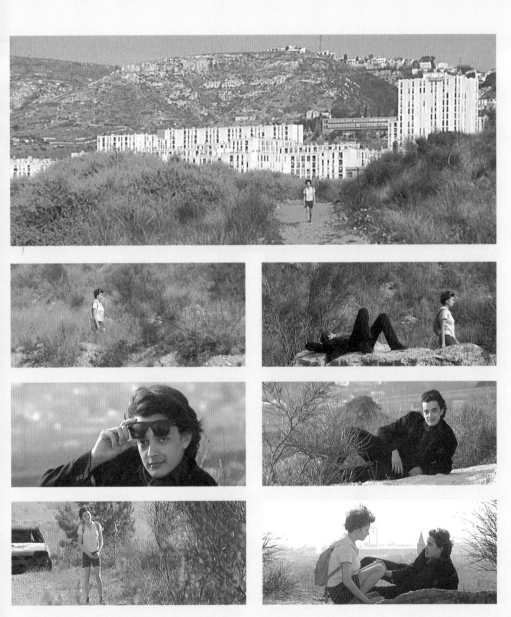

Images © 1993 Gaumont, France 3 Cinema, Ciné Valse

BYE-BYE (1995)

La Canebière

THE CULTURAL AND ETHNIC DIVERSITY of Marseilles, itself on the periphery of France, makes this port city a striking choice as background for Karim Dridi's 1995 film *Bye-Bye*. The film traces a series of departures across geographic spaces for two brothers: Ismaël (Sami Bouajila) and Mouloud (Ouassini Embarek). Following the tragic death, in a fire, of their wheelchair-bound brother in Paris, the film opens with the brothers' arrival in Marseilles. Ismaël has promised his father that he will send Mouloud to join their parents in Tunisia. While this promise is never realized, it nonetheless serves as a catalyst for the conflict that arises between the siblings, and also underscores the rift between traditional values and gritty, urban unrest that applies to the larger community. Mouloud asserts his independence by befriending his misguided cousin Rhida (Sofiane Mammeri), and Rhida's drug-dealing idol/boss, the violent, psychopathic Renard (Moussa Maaskri). In this sequence, Ismaël sets off on a nocturnal quest in search of Mouloud and roams La Canebière, a central avenue of downtown Marseilles. Ismaël's task is an impossible one: he is framed walking against the flow of traffic with city lights that recall Marseilles' dense population. As he stops to ask passers-by if they have seen Mouloud, Dridi's film assumes a quasi-documentary feel with Ismaël appearing as a man on the street; his interactions with older shopkeepers and younger tourists document the diverse nature of this port city. Ismaël's missed encounter with Mouloud – who passes by, unseen in Renard's glamorous convertible – reflects the seductive lure of crime culture into which his younger brother is falling. **↦Adrienne Angelo**

Photo © Gabriel Solomons

Directed by Karim Dridi
Scene description: Ismaël searches for his younger brother, Mouloud, who has gone missing
Timecode for scene: 0:47:00 – 0:48:39

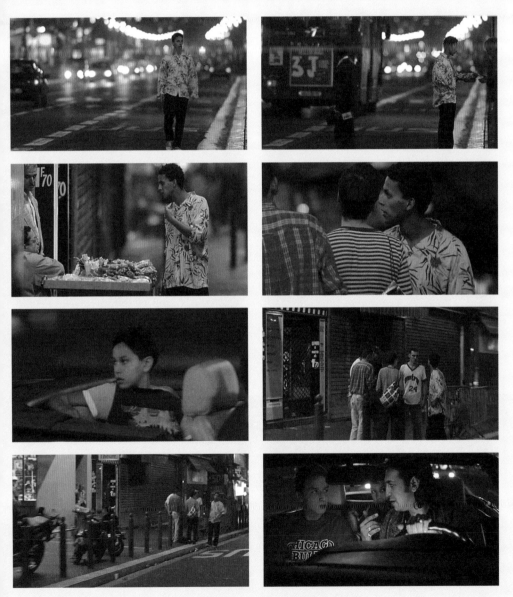

LITERALLY SPEAKING

*Cinematic Adaptations of
Jean-Claude Izzo's Marseilles Novels*

Text by
GEORGIANA
M.M. COLVILE

POET AND NOVELIST Jean-Claude Izzo (1945–2000) remains a crucial figure of Marseillais arts and letters. Born in the Panier district to an Italian father and mother of Spanish descent, Izzo embodied the pan-Mediterranean atmosphere of his native city and beloved muse. Izzo first became famous as a journalist and organizer of cultural festivals, then for his poetry, crime fiction and drama, usually set in Marseilles. He emphasizes the city's sensuality, rakish charm, beautiful seashore, ocean liners, fishing boats, white houses by turquoise water; as well as its trade, fights, gambling, alcoholism, drugs, racketeering, and shady deals concluded in the smoky bars, restaurants, and clubs at the centre of the Phocaean port. 'Marseilles is closest to my heart,' said Izzo, whose heroes love her as passionately as they do their women, the way Marseillais worship the church of Notre-Dame de la Garde ('The Good

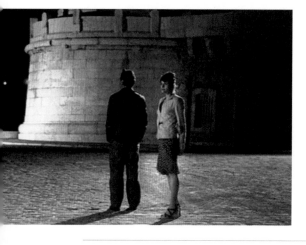

Mother') watching over the harbour from the city's highest hilltop. Two of Izzo's novels are adapted for the screen: *Total Khéops/Total Chaos* (Alain Bévérini, 2002) and *Les marins perdus/The Lost Sailors* (Claire Devers, 2003).

Total Chaos is Volume I of a noir trilogy relating the adventures of Izzo's protagonist, Fabio Montale, a robber turned cop. Bévérini, a Marseillais radio and TV reporter, made the film as a tribute to his friend Izzo, who died of cancer in 2000 at age 54. Give and take a few eliminations, name changes and alterations in the order of events, Bévérini remains true to the atmosphere and contradictions of Izzo's Marseilles in his book. *Total Chaos* tells the story of four inseparable friends (aged 18–20), three boys from the Panier – Fabio (Richard Bohringer) and Ugo (Robin Renucci), both Italian, and the Spanish Manu (Daniel Duval) – later joined by mysterious, seductive Lole (Marie Trintignant), a Romani girl from Seville. Bévérini cuts between the past – as the older Fabio recalls it – and the present, while pacing the narrow streets of the Panier, driving along the Canebière or up to Les Goudes, a coastal fishing village. Now middle-aged, having gone their separate ways, the friends remain nostalgically loyal to their youthful bond. Early gangsterism ended badly: prison for Manu, exile as a mercenary soldier for Ugo, the corrupt police force for Fabio. Returning to Marseilles, Manu and Ugo meet sticky ends. Fabio sets out to avenge his friends, as well as a young Algerian woman who was raped and assassinated. The camera tracks and pans, following Fabio all over Marseilles until every culprit is apprehended.

The film is structured like a medieval chivalry

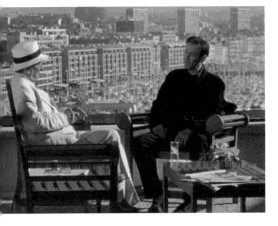

Above © 2002 EFrance 2 Cinéma, Les Films de la Castillere, Ognon Pictures Opposite © 2003 Maurice Bernard Salome, Studio Canal

story, with Fabio as the ideal knight, fierce at times, defending the weak. His enemies are local gangsters, Italian Mafiosi, extreme-right Arab bashers, hostile colleagues, his friends' murderers. On his quest for justice, he encounters helpers and adversaries, uncovers a criminal network and wins his love, Lole. Bévérini's camerawork is rhythmic and symmetrical. The circular film opens and closes with lyrical tracking shots of the sea and high angles of Fabio and Lole in his fishing boat, which, like his cabana at Les Goudes, symbolizes a private Shangri-La. The garish colours and loud music of the flashbacks are contrasted with the sober blue-grey present of Fabio's solitude.

Total Chaos is Bévérini's only feature film. In an interview, he states that, 'I had to settle my accounts with the city by filming it. I could turn J.C. Izzo's story and characters into my own. That contradictory love-hate feeling needed to be expressed through images.'

The Lost Sailors, with its glamorous cast, presents the story of a cockroach-infested freighter, the *Aldébaran*, condemned to remain in Marseilles' La Joliette harbour as a guarantee for its owner's debts. Lebanese captain Aziz (Miki Manojlovic) obtains a pittance for the men if they choose to depart. All accept, leaving Aziz and his

> 'I had to settle my accounts with the city by filming it. I could turn J.C. Izzo's story and characters into my own. That contradictory love-hate feeling needed to be expressed through images.'
> – Alain Bévérini, Director of *Total Khéops*

Greek first mate Diamantis (Bernard Giraudeau) on-board. The naive young Nedim (Sergio Peris-Mencheta) joins them after squandering his pay in a bar, led on by Lalla (Audrey Tautou).

Stranded between land and sea, the men form a tense trio, as in Sartre's *No Exit*. Aziz hates Nedim, who fears him, while both trust Diamantis. Each hides a secret connected to a woman: Aziz dreads his African wife leaving him; Diamantis seeks forgiveness from the woman he abandoned in Marseilles long ago; Nedim longs to marry a woman whom he raped before going to sea. On shore, Aziz purchases the services of a Russian prostitute; Nedim shares puppy-love with Lalla; Diamantis falls for Mariette (Marie Trintignant).

Devers rejects the women's key roles in Izzo's book, dwelling instead on the men's 'homosocial' (cf. Eve Kosofsky Sedgwick, *Between Men*, 1985) interaction. Where Izzo identifies with Diamantis, Devers is enthralled by him, not only as the handsome Giraudeau, but also for his effect on the other males and his role in their group dynamic. He doesn't jump ship, having nowhere to go, just as Montale never desired to leave Marseilles. An astute Ulysses, Diamantis is also kind. He saves Nedim by paying his debt, and tries to help Aziz overcome his self-loathing. He is non-violent and tends to lose fights, yet, like Montale, he challenges pimps and other criminals in order to defend their victims.

Devers maintains the cathartic scene between Aziz, Nedim and Lalla. After reluctantly accepting the girl's illegal request to visit the ship, the captain gets drunk, savagely murdering Nedim. Diamantis then attempts to save Aziz, who refuses to plead accidental manslaughter and is led away by the police. The film ends with Diamantis driving Nedim's coffin to the boy's village in Turkey, stopping to phone Mariette, now reduced to her voice. Male bonding, albeit posthumous, comes first.

Although Devers has made cuts to the source material, blurring the meaning of Izzo's narrative, her camerawork renders its atmosphere. Her use of a blue lens, cross-cutting and spatial fragmentation for the *Aldébaran*'s cabins evokes the men's claustrophobia, especially in contrast with the summer light on the docks illuminating Lalla's dress. Throughout the film, the characters' confusion is highlighted by an interior/exterior montage, alternating between the boat or city bars, and the open spaces of Marseilles and the sea. ✢

MARSEILLES

maps are only to be taken as approximates

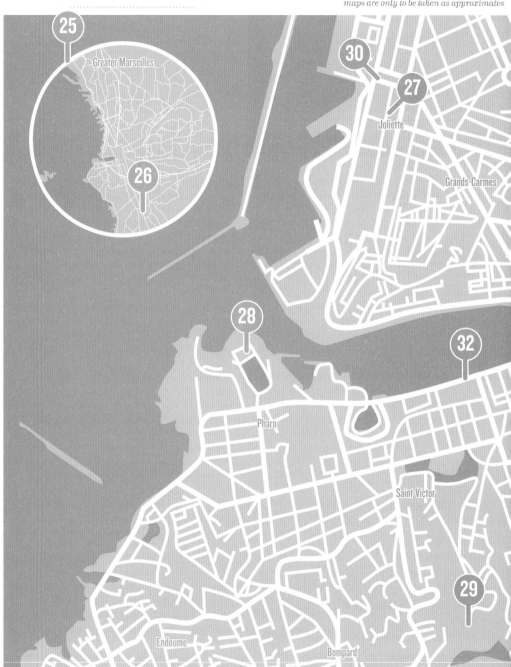

MARSEILLES LOCATIONS
SCENES 25-32

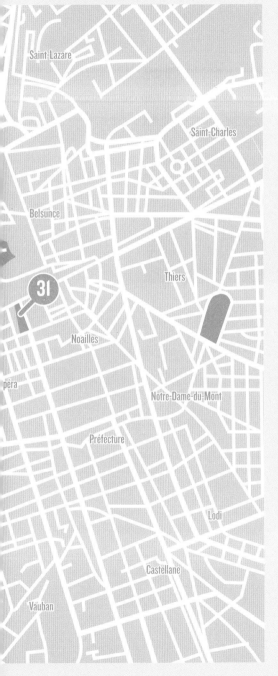

MARIUS AND JEANNETTE/ MARIUS ET JEANNETTE (1997)

L'Estaque on the outskirts of Marseilles proper

THE HUMANISM OF JEAN RENOIR lives on in *Marius and Jeannette*, a life-enhancing Marseilles *comédie dramatique* of 1997, written and directed by Robert Guédiguian. This love story of working-class characters is permeated with affection for all the fallible members of their community. Jeannette (Ariane Ascaride) is a loud-mouthed supermarket cashier and loving single mother to Magali and Malek. She first meets Marius (Gérard Meylan) – a guard in a soon-to-be-demolished cement factory – when she tries to steal paint. Although he stops her, he later brings the cans to her home and helps her paint. Thus begins the tentative love between people in their forties who look more like Italian neo-realist extras than movie stars. Guédiguian's deceptively simple frame encompasses politics and religion: we hear the scorn Monique (Frederique Bonnal) heaps on her husband, Dédé (Jean-Pierre Darroussin), because he once voted for the far-right. Retired teacher Justin (Jacques Boudet) gives a wonderful lesson to Malek (who is black and Muslim) about the intolerance of fundamentalists. He also pines for the ever-sexy neighbor Caroline (Pascale Roberts), who survived a Nazi camp. In one of the key scenes that is both realistically detailed and symbolic, they make the Provençal specialty of aioli: Marius, Dede and Justin grind the ingredients of the garlicky sauce, while Jeannette, Caroline and Monique prepare the eggs, vegetables and fish that will be dipped. The scene is emblematic of Guédiguian's vision of interconnectedness: whether it is an aromatic dish or a moving film, the whole is greater than the sum of its parts. **•* Annette Insdorf**

Photo © Josimon (Panoramio)

Directed by Robert Guédiguian
Scene description: Making the Aioli
Timecode for scene: 1:05:23 – 1:08:10

Images © 1997 Agat Films & Cie, La Sept cinéma, Canal+

TAXI (1998)

DANIEL (SAMY NACERI) and Émilien (Frédéric Diefenthal) speed north along the Boulevard Michelet, pursued by two Mercedes filled with German bank robbers. The two men were brought together by their desire for change: Daniel would like to trade in his taxi for a job on the racing circuit, while Émilien hopes to gain the respect of his police department colleagues. Daniel's love of speed results in this alliance; in order to avoid losing his taxi he agrees to help Émilien lure the bank robbers into a trap by challenging them to race. They do just that across the southern suburbs of Marseilles, weaving in and out of traffic. On several occasions, Daniel's taxi narrowly avoids collision; first-person camera shots of him veering into oncoming traffic add to the tension. Daniel's friends are stationed along the boulevard, each one responsible for accessing the traffic box at an intersection and ensuring that no red lights slow him down. The tension increases when Émilien radios ahead to one such helper who cannot discharge his mission because two traffic cops are stationed nearby. Émilien, whose mind works as fast as Daniel drives, convinces the cops to break into the traffic box themselves in order to defuse a fictitious bomb. The light turns just as Daniel and Émilien speed through the intersection. The bank robbers are captured, Daniel joins the racing circuit, and Émilien gets his promotion, but above all else the culminating race scene in *Taxi* suggests that the Mediterranean city is modern and vibrant. ↩ ***Andrew Howe***

Photo © Gabriel Solomons

Directed by Gerard Pirès
Scene description: *Turning the traffic lights red*
Timecode for scene: *1:14:34 – 1:15:40*

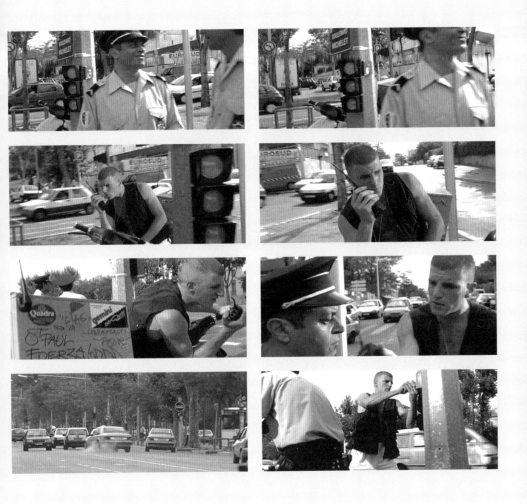

THE TOWN IS QUIET/
LA VILLE EST TRANQUILLE (2000)

LOCATION Port de Marseille Fos, La Joliette

ROBERT GUÉDIGUIAN'S FILM opens with an impressive 360-degree panning shot of the roofs of Marseilles, evoking a beautiful and tranquil image *à la* Cézanne. But when he cuts to the scene in question, we find gathered on the docks a crowd of disgruntled workers on strike. Due to political chicanery, ideological corruption and the seeking of huge profits in gentrification, most, if not all, of the dock workers face redundancy. Among the throng of picketers stands Paul (Jean-Pierre Darroussin). Unlike his fellow workers, who cry 'Les dockers solidaire!' for unity and solidarity, Paul contemplates crossing the picket line by accepting his severance money, so as to set up his own business as a cab driver. This choice to leave the docks and become a cab driver is a decision that will involve Paul in the complex, dysfunctional family of Michèle (Ariane Ascaride). Michèle, a young grandmother, is compelled to prostitute herself in order to supply drugs to her addicted daughter. The lives of several other Marseillais cross paths with Paul and Michèle, including xenophobes, assassins, teachers and former communists, all of whom live in similarly tragic circumstances; thus, when seen through Guédiguian's critical lens, Marseilles seems to possess none of the tranquility with which we saw in the film's opening frames. **✒Zachariah Rush**

Photo © Isabelle Marcangeli

Directed by Robert Guédiguian
Scene description: 'Les dockers solidaire!'
Timecode for scene: 0:06:38 – 0:07:38

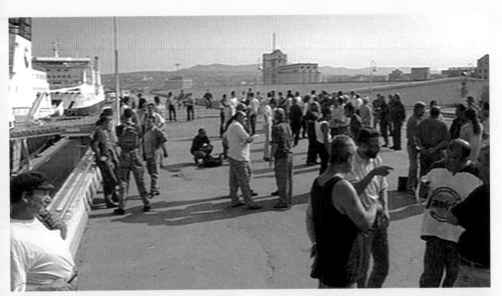

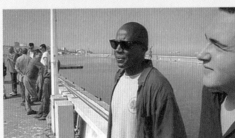

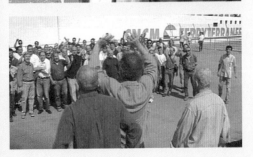

TAXI 2 (2000)

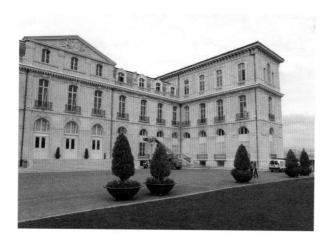

THE START OF TAXI 2 finds Daniel Morales (Samy Naceri) back behind the wheel of his famous white taxi and making great time. This second installment of the extremely successful *Taxi* franchise centres on a yakuza plot to kidnap the Japanese minister while he is on an official visit to Marseilles – a plot that ultimately fails. Daniel's friend Émilien (Frédéric Diefenthal) is still an innocent cop in need of help, and Daniel's girlfriend, Lilly (Marion Cotillard), is still waiting for him to return from his adventures. Added to the mix is Lilly's father, Général Bertineau (Jean-Christophe Bouvet), who has been told Daniel is a medical student rather than a taxi driver. As always, Daniel has a need for speed: his two anxious passengers are a woman in labour and her disoriented husband. Passing race car driver Jean-Louis Schlesser mid-course and beating him across the finish line, Daniel proves once again that he and his taxi are the fastest thing on the road. Daniel delivers his passengers to the Clinique du Pharo (set in historic Palais du Pharo, a palace built for Napoleon III). As the taxi stops, the woman gives birth to her baby in the backseat.
→Kristiina Hackel

Directed by Gérard Krawczyk
Scene description: Special delivery in Daniel's taxi
Timecode for scene: 0:02:10 – 0:07:04

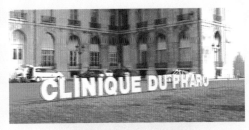
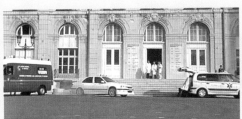
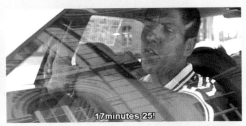
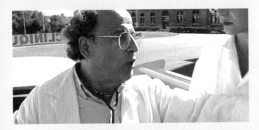
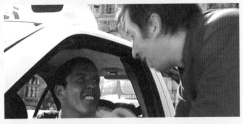

BELLA CIAO (2001)

LOCATION *Notre Dame de la Garde (golden statue of the Virgin with child), Rue Fort-du-Sanctuaire*

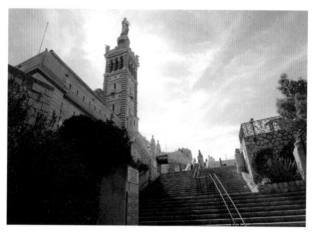

PERSECUTED BY BENITO MUSSOLINI'S blackshirts for being communist, the Mancini family decides to immigrate from Italy to the United States, although in their haste to escape they board the wrong ship. The truth is realized as their young son, Oreste, looks through a porthole and describes what he believes to be the Statue of Liberty, which is actually the statue of the Madonna and child overlooking Marseilles' harbour from atop the basilica of Notre-Dame de la Garde . When he mentions that the statue is holding a baby, his father corrects him by saying, 'Lady Liberty doesn't have any children!' This statement is ironic, considering that the Mancini family will now be both political and ethnic minorities in a France soon swept up in World War II. A short while after disembarking, the dejected Mancinis sit by the waterfront of the Vieux-Port, a place that will become a site of both solidarity and suffering for the family. The coming war brings tragedy: Oreste's father is beaten to death by fascist agents and his sister dies at the old *quai* during an allied bombing raid. However, the waterfront will also come to represent a connection to the past. By the end of the narrative, Oreste has stayed true to his Italian roots, but has been accepted by his French community. Furthermore, his son is a successful doctor, suggesting that liberty can, in fact, follow in the wake of suffering and sacrifice. And during his final moments by the waterfront, Oreste teaches his granddaughter an important lesson in family history. **•» Andrew Howe**

Photos © Jean-Luc Lioult

Directed by Stéphane Giusti
Scene description: 'Lady Liberty doesn't have any children!'
Timecode for scene: 0:14:08 – 0:15:33

Images © 2001 Canal +, Elzévir Films, France 3 Cinéma

THE TRANSPORTER/LE TRANSPORTEUR (2002)

Port de Marseille Fos, 23 Place de la Joliette

THIS EUROPEAN-US ACTION FRANCHISE is built around Frank Martin (Jason Statham), a retired special operative now hired to transport packages throughout the French Mediterranean. The extended sequence in the Marseilles container yard and adjacent bus terminal follows Martin as he attempts to recover a shipping container filled with Asian slaves, who have been transported by a corrupt Chinese businessman and his American lieutenant known as Wall Street (Matt Schulze). Martin enters the maze of containers late at night from the harbour. After a brief fight, Wall Street orders the first band of thugs to subdue Martin. Martin uses the doors of the containers to deflect, hit and contain the gang. Climbing to the top of a container, he leaps onto the truck carrying the contraband to Lyon. However, as the truck driver merges onto the highway, he manages to throw Martin off. Martin drops from the overpass onto the roof of a France BLEU Provence bus, returning him to an empty Marseilles bus terminal. Emerging from the maze of parked buses, Martin fights two more bands of thugs, first in a bus interior, then in a garage, improvising with the materials available to subdue these groups in hand-to-hand combat. When a final band of thugs enters with machine guns, Martin falls strategically back into the harbour. Diving below an oil fire, he briefly returns to the terminal to get keys and his shirt, and to pursue the human trafficking convoy. This sequence establishes Frank Martin's mastery of transportation in the city of Marseilles. **∞Elizabeth Abele**

Photo © www.allaboutshipping.co.uk

Directed by Louis Leterrier and Corey Yuen
Scene description: Frank Martin fights thugs as he tries to rescue the human cargo being trafficked
Timecode for scene: 1:08:31 – 1:16:55

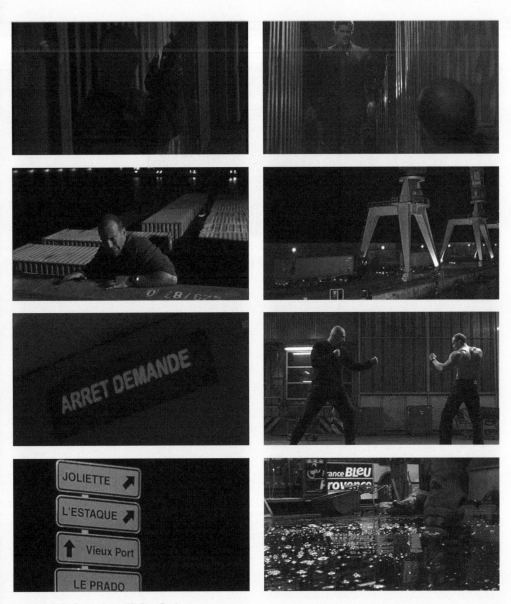

Images © 2002 Europa Corp., TFI Films Production

PAYOFF/GOMEZ & TAVARÈS (2002)

LOCATION *Arc de Triomphe in Marseilles: Porte d'Aix, Place Jules-Guesde*

CARLOS GOMEZ'S (STOMY BUGSY) first view of Marseilles when he arrives from Paris by car is the Avenue Camille-Pelletan. This scene is of particular importance in *Payoff*: Gomez has just been transferred to a police station in France's second largest city, Marseilles, and now he must team up with Max Tavarès (Titoff), a local detective. Since the camera does not show us Gomez's face, this shot gives the illusion that we are discovering the Phocaean City along with him. One cannot help but notice a sharp contrast between the French capital's Champs-Elysées and Marseilles' own Arc de Triomphe district. Though both urban sites are contemporary, their immediate surroundings oppose each other. The Parisian *huitème arrondissement* is supposedly the culmination of the French capital's elegance (and *snobisme*): all the avenues that converge at the Place de l'Etoile are part of an upper-class, chic, touristy and idealized environment. By contrast, its equivalent in Marseilles, Avenue Camille-Pelletan, which leads to the Porte d'Aix at the Place Jules-Guesde, seems to have remained a working-class, immigrant neighbourhood. Ironically, Avenue Camille-Pelletan will soon become a piece of forgotten history since it is scheduled to fall prey to future gentrification, as part of the *projet euro-méditerranée* of urban development. **↦Henri-Simon Blanc-Hoàng**

Directed by Gilles Paquet-Brenner
Scene description: *Arrival of Gomez in Marseilles*
Timecode for scene: *0:15:49 – 0:15:54*

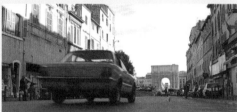

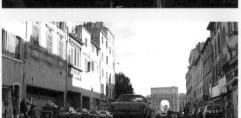
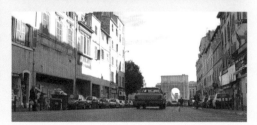

TOTAL CHAOS/TOTAL KHÉOPS (2002)

*Notre-Dame-des-Accoules steeple and belltower (Tour de Sauveterre),
Montée des Accoules, 10 Place Daviel*

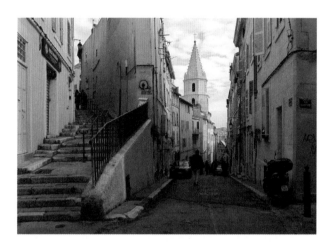

TOTAL CHAOS IS ADAPTED FROM Jean-Claude Izzo's *Marseilles Trilogy*
detective novels (1995–98), which differ widely from Marcel Pagnol's iconic
Marseilles trilogy. Centred upon protagonist Detective Fabio Montale
(Richard Bohringer), *Total Chaos* is infused with the cultural atmosphere of
Marseilles, from its Provençal cooking, to its dramatic coastline, to its criminal
undercurrents. *Total Chaos* depicts, through flashbacks, events that occurred
twenty years prior to the unfolding narrative, when a bond between three
inseparable friends – Fabio, Manu (Daniel Duval) and Ugo (Robin Renucci)
– was broken, after a crime they committed forced them to separate: Manu
into the Marseilles underworld; Fabio joining the city's police force; and Ugo
fleeing the country. Ugo returns to Marseilles, seeking vengeance for Manu's
recent murder by assassinating a powerful don, Zucca. Afterward, he returns
to the Panier, where he is staying with Lole (Marie Trintingnant). Zucca's men
await him at the base of the Montée des Accoules; they kill him, execution-
style, under bright midday sun. The scene is watched over by the steeple of the
Accoules church. Most of this church was destroyed in the years following the
French Revolution, but was rebuilt in the 19th century. Its 14th-century *clocher*
(bell tower) – built on the 10th-century Tour de Sauveterre – still stands. Ugo
expires on the Montée des Accoules, which winds from the Place de Lenche to
the Place Daviel, while in the background, church bells ringing, birds chirping,
and the happy voices of children at play contrast with the violence of his final
hours. Alas, poor Ugo: life goes on in the Phocaean City's Panier – as it has for
thousands of years – oblivious to his suffering and death. **•❖Marcelline Block**

Photo © Gabriel Solomons

Directed by Alain Bévérini
Scene description: Alas, poor Ugo!
Timecode for scene: 0:35:51 – 0:36:16

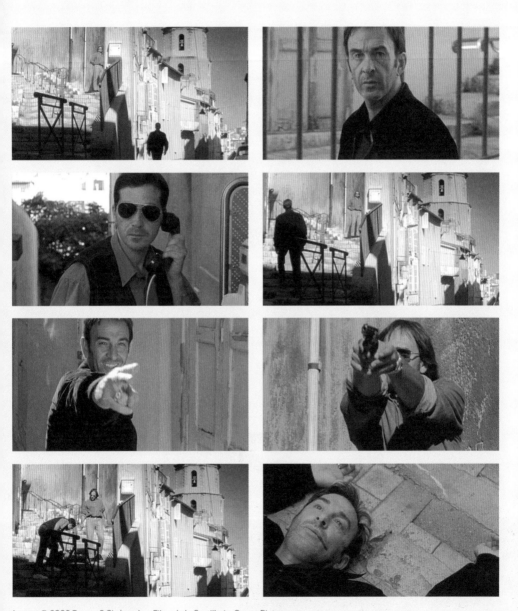

MELTING POT

Immigrants, Refugees and Stateless Characters

Text by
HENRI-
SIMON
BLANC-
HOÀNG

FOR THE PAST SEVERAL DECADES, many French film directors have represented the struggles and plights of immigrants. Not surprisingly, these film-makers are also the ones who are most likely to avoid stereotypical depictions of Marseilles. Their choices for shooting locales in this city indicate transience and displacement (harbours, the coast, airports); domestic environments (immigrant neighbourhoods and homes); and subversions of locations signifying tradition, such as churches.

In *Bella Ciao* (Stéphane Giusti, 2000), the harbour and the coast are the main sites that bear witness to immigrant assimilation in Marseilles: it is where the Mancini family disembarks the ship from Italy; as romantic meeting places for lovers; as sites of socialization and of mourning (where two of the main characters meet their deaths).

In *L'Italien/The Italian* (Olivier Baroux, 2010), the Marseilles airport becomes a place of shifting identity. In this film, Mourad (Kad Merad), a French citizen of Algerian descent, pretends to be an Italian national named Dino in order to escape racial prejudice. Mourad leads his family to believe that he works in Italy to prevent his relatives from visiting him in Nice (where he actually holds his job) and possibly reveal his identity. Upon arriving

at Aéroport Marseille-Provence, Mourad/Dino must act as if his flight has just landed from Rome in order to maintain this deception. When he meets his mother at the gate, Dino the Italian has reversed into Mourad the Arab.

The cultural microcosms that make up immigrant neighbourhoods are places of transition for newcomers. In *Mother* (Henri Verneuil, 1991), Armenian refugee Azad Zakarian (Stéphane Servais) calls himself Jean-Pierre outside of his Marseilles home once he graduates from boarding school. Subsequently, in the film's sequel, *588 rue Paradis* (Henri Verneuil, 1992), the same Azad Zakarian is now living in Paris as Pierre Zakar (Richard Berry), a new name suggested by his socially ambitious wife. In *Bella Ciao*, three generations after the Mancini family immigrate from Italy to Marseilles, grandson Gianni Mancini (Nicolas Cazalé) becomes 'Jean Mancin' when he ventures out of his neighbourhood to receive a prestigious award at a ceremony at his school.

Catholic imagery represents other moments of transition and transformation. In *Bella Ciao*, the only shot of Notre-Dame de la Garde is indirectly subverted. Because the statue of the Madonna is shown only as a close-up, viewers cannot determine its real size. As a result, it could very well be a small statue of the virgin that one would find inside of a church or a home. Since this is the first view of Marseilles that the Mancini family sees, this image function as a subliminal message for the audience: newcomers can enjoy freedom of worship in France, but it is better to express one's religious beliefs privately. In *A la place du coeur/Where the Heart Is* (Robert Guédiguian, 1998), another Catholic image is subverted when Bébé (Abdramane Diakite), who was adopted from Africa by a Caucasian family in Marseilles, decides to become a sculptor after observing a statue of Jesus during a visit to the basilica. Years later, 18-year-old Bébé (Alexandre Ogou) carves a figurine resembling the baby Jesus inside a bar

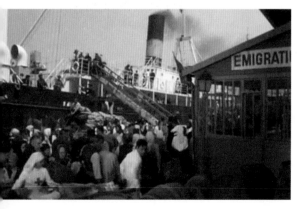

Above © 2000 EFrance 2 Canal+, CNC, Eskwad
Opposite © 2003 Carthago Films S.a.r.l, Quinta Communications, TFI Films Production

of Marseilles soap for his pregnant girlfriend. A religious figure from the famous cathedral has become the inspiration of a completely secular work of art created by an African immigrant.

Progressive directors do not necessarily ignore traditional images of the Phocaean City, but rather contrast them with the harsh reality of immigrants' everyday lives. In *Comme un aimant/The Magnet* (Akhenaton & Kamel Saleh, 2000), a scene that takes place near the Cathedrale Sainte-Marie-Majeur, a legacy of the pseudo Romano-Byzantine architectural style of the nineteenth century, reveals a close-up of Cahouètte (Kamel Saleh), a French citizen of Maghrebian descent, who has just been released from the nearby Hôtel de Police. Here, two worlds collide: shown in the background is the postcard snapshot of Marseilles with its Romano-Byzantine religious architecture, which, for tourists and natives alike, defines the city as much as does the *pastis-pétanque-bouillabaisse* trinity, while the police station, featured in the foreground, is a reminder of what confronts the children of immigrants.

La ville est tranquille/The Town is Quiet (Robert Guédiguian, 2000) relies on a similar contrast. In a single sequence, we first see Abderamane (Alexandre Ogou), the son of an African immigrant family, swim in the sea with his friends. On his way back to the housing project, a hostile right-wing neighbour shoots Abderamane to death. Once again, two views of

Progressive directors do not necessarily ignore traditional images of the Phocaean City, but rather contrast them with the harsh reality of immigrants' everyday lives.

Marseilles are opposed: bucolic life by the coast and urban violence.

There is also a significant contrast between films set in the early decades of the twentieth century and those set in twenty-first century Marseilles. In the 1930s of both *Bella Ciao* and *Mother*, southern European immigrants experience racism. In *The Italian*, the contemporary character Mourad Ben Saoud changes his name to Dino Fabrizzi, since Italians are now considered 'honorary whites'. This 'privilege' granted to southern European immigrants is revealed again in *Les marins perdus/ The Lost Sailors* (Claire Devers, 2003), where the entire crew of a cargo ship is stuck in the harbour because its owner has not paid his suppliers. One by one, the unemployed sailors leave the country, are arrested or are killed. Only one crew-member ends up settling in Marseilles: Diamantis (Bernard Giraudeau), a Greek – in other words, a European – who was the ship's second in command.

Although the above mentioned motion pictures criticize racism directed towards immigrants to a certain extent, idealized views of the French model of assimilation are still alive and well in many mainstream films shot in Marseilles, such as the *Payoff* duology – *Gomez & Tavarès/Payoff* (Gilles Paquet-Brenner, 2003) and *Gomez & Tavarès, la suite* (Gilles Paquet-Brenner & Cyril Sebas, 2007) – or the *Taxi* series ([Gérard Pirès, 1998], [Gérard Krawczyk, 2000; 2002; 2007]), all written by Luc Besson. In *Payoff*, Carlos Gomez (Stomy Bugsy), a Parisian detective from a Capoverdean immigrant family, is transferred to a Marseilles police precinct and ends up partnering with an old-stock Frenchman, Max Tavarès (Titoff). Despite their racial difference, when the two detectives interact with representatives of different ethnic communities in Marseilles, racism and discrimination seem to be a thing of the past. In the *Taxi* series, *beur* actor Samy Naceri (b. 1961) plays the role of Daniel Morales, a cab driver of Portuguese descent. In these films, however, no one seems to question the whiteness of this character. Ironically, Naceri's real first name is Saïd, which he had to change earlier in his acting career for the same reasons that Azad Zakarian calls himself Pierre Zakar in *Mother* and Mourad ben Saoud pretends to be Dino Fabrizzi in *The Italian*. While comedy and action film directors often choose to ignore the realities of racism in France, other films present a richer and more nuanced view of the immigrant experience in Marseilles. ✣

MARSEILLES

LOCATIONS MAP

maps are only to be taken as approximates

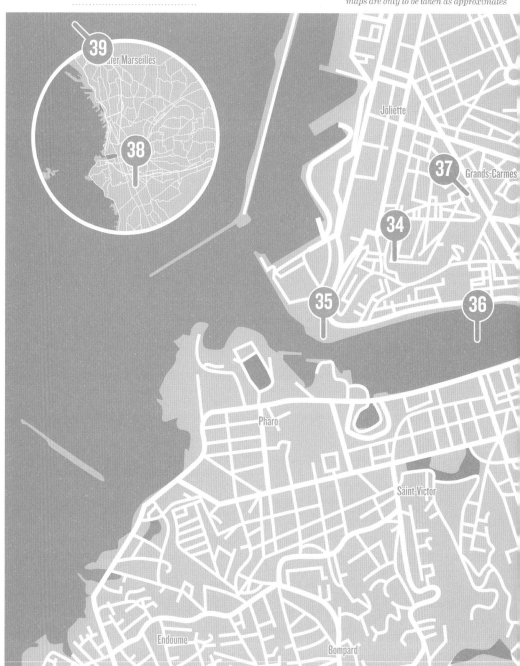

MARSEILLES LOCATIONS
SCENES 33-39

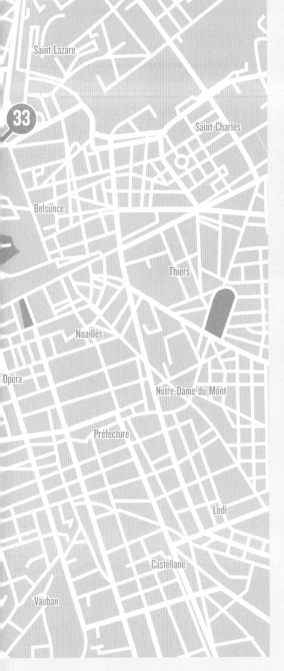

THE LOST SAILORS/
LES MARINS PERDUS (2003)

Fontaine de la place du Général-de-Gaulle; La Belle Epoque carrousel

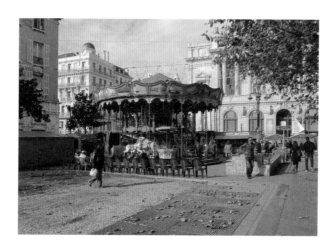

DIAMANTIS (BERNARD GIRAUDEAU), first mate of the cargo ship *Aldébaran,* has retrieved the belongings of sailor Nedim (Sergio Peris-Mencheta) from a bar where they are being held as collateral until he pays his bill. Nedim shows Diamantis a photograph of his parents that he joyfully kisses. Diamantis' gruffness is offset by the happy-go-lucky Nedim. Diamantis, sensing that Nedim's liaison with coquettish Lalla (Audrey Tautou) will bring trouble, insists that Nedim leave Marseilles immediately. Diamantis' request is premonitory, as confirmed by the tragic ending of the film aboard the *Aldébaran.* The *Aldébaran,* confiscated because of its owner's debt, is moored in the harbour. The crew has departed, except for Nedim, Diamantis and Captain Aziz (Miki Manojlovic), who have nowhere to go and therefore remain onboard. Unlike the gloomy *Aldébaran,* the bustling Canebière is alive with a festive atmosphere, punctuated by the Belle Epoque Carrousel's upbeat music, wooden horses and twinkling lights. Carved into the concrete fountain on the Place du General-de-Gaulle is the motto (in Latin), 'By her great deeds, the city of Marseilles shines' – a sentiment reinforced by the adjacent plaque honouring the city's Free French and Resistors. Nedim and Diamantis stand in front of this inscription, partially obscuring it. As Nedim rushes by the World War II plaque, its dedication to the aerial, naval and ground troops is blurred, yet should not be overlooked, as it provides a counterpoint to the film's brutal ending. Adapted from Jean-Claude Izzo's novel, *The Lost Sailors'* horrific denouement is overdetermined by the casting of Marie Trintignant as Diamantis' love interest. Marie Trintignant, herself a victim of brutal violence at the hands of her boyfriend, died on 1 August 2003 of the injuries he inflicted on her – just one month after the film's premiere in France that July. **•◦ Marcelline Block**

Photo © Gabriel Solomons

Directed by Claire Devers
Scene description: Diamantis returns Nedim's belongings, stating, 'It's time for you to leave'
Timecode for scene: 0:56:04 – 0:57:27

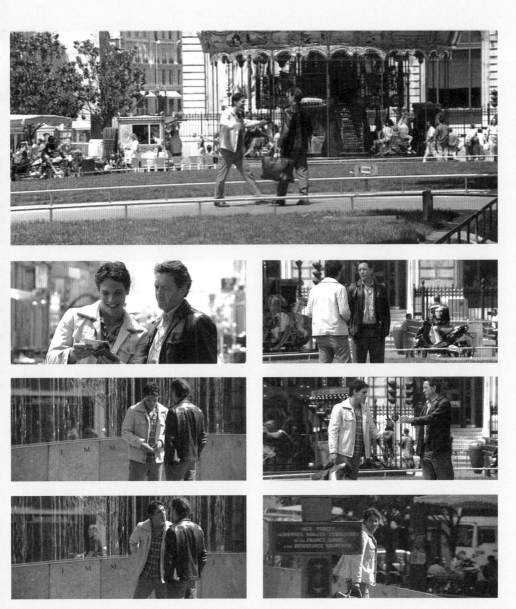

LOVE ACTUALLY (2003)

LOCATION *Bar de la Marine, Vieux-Port, 15 Quai de Rive Neuve*

THIS FILM FOLLOWS INTERCONNECTED STORIES of love's (mis) connections during the holiday season, set primarily in London. The only continental European storyline unfolds around Marseilles, between English Jamie (Colin Firth) and Portuguese Aurelia (Lúcia Moniz) – neither of whom speak French nor each other's language when they first meet. This scene happens after Jamie has abruptly left his family gathering for Marseilles to propose to Aurelia. Her family and neighbours escort Jamie through dark alleyways of Marseilles to the Le Bar de la Marine, the 'Portuguese restaurant' where Aurelia works. With the restaurant's levels, the framing of the balcony and staircases by cast-iron railings, and other architectural details like arches, posts, beams and cornices, the interior mirrors a Marseilles streetscape. This effect is furthered by murals of port scenes and the yellow walls, which evoke the famed light of Provence. In entering the Bar de la Marine, Jamie walks from a Marseilles nightscape into 'daylight'. In Romeo-and-Juliet fashion, Aurelia stands at the balcony with Jamie below. Surrounded by Aurelia's Portuguese community, Jamie declares his love to Aurelia in faulty Portuguese, asking her to marry him. Aurelia accepts him in equally faulty English, descending the staircase to everyone's applause. When she kisses Jamie, they are framed by the bar area, with hanging garlic, wine bottles and bowls of fruit visible, reminiscent of a Mediterranean kitchen, as they seal their domestic future. Marseilles functions in this film as a symbol of European union, as nationals of two European countries find love in a third.
➠*Elizabeth Abele*

Photos © Gabriel Solomons

Directed by Richard Curtis
Scene description: Jamie proposes to Aurelia
Timecode for scene: 2:03:53 – 2:07:32

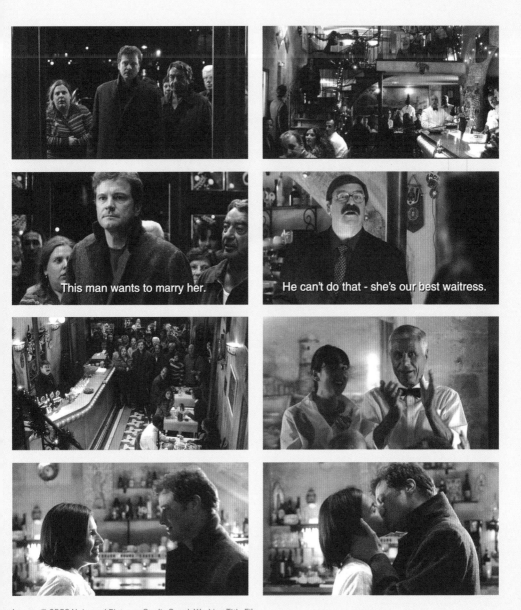

THE STATEMENT (2003)

LOCATION *Vieux-Port, Digue Du Fort Saint-Jean*

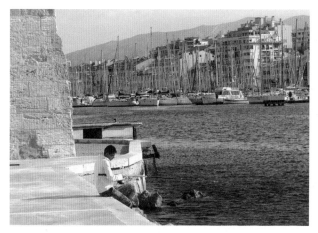

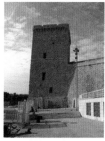

INSPIRED BY A TRUE STORY, Norman Jewison's *The Statement* (2003) is about Pierre Brossard (Michael Caine), a man on the run. Brossard – a French Nazi collaborator who assisted in the deaths of several French Jews during the German occupation of France – escaped prosecution after the war by seeking refuge through a group inside the Catholic Church. Since then he has remained protected within a kind of morally compromised sanctuary, a sinister 'underground railroad' for Nazi collaborators. By travelling to abbeys throughout France – Castillon, Aix-en-Provence, Frejus, and Nice – Brossard has managed to stay hidden for decades. But by the early 1990s his luck has run out when a French judge (Tilda Swinton) is assigned to prosecute him for crimes against humanity, and a mysterious vigilante group twice attempts to assassinate him. At first thought to be the work of 'Jewish activists', it is later discovered that his own supporters have orchestrated the assassination attempts, fearful that if he were caught, Brossard would name other Nazi collaborators. This scene begins with a wide view of the port of Marseilles where Brossard has fled. He walks along it looking at boats. His internal voice-over asks: 'Why not go far away, rent a boat, and "just disappear?"' As he turns and looks at the basilica on the hill, however, he thinks: 'No. The Church is my only refuge, my hiding place. I must go on.' As he does go on, fleeing his pursuers, he inevitably travels toward his own death, depicted at the end of the film. **↝Tina Wasserman**

Directed by Norman Jewison

Scene description: *Pierre Brossard realizes that the Church is his only refuge*

Timecode for scene: *1:16:00 – 1:16:44*

A TALKING PICTURE/
UM FILME FALADO (2003)

Plaque about the Foundation of Marseilles, Vieux-Port

THE AGELESS MANOEL DE OLIVEIRA was barely in his nineties when he directed *A Talking Picture*. After they set sail from Lisbon, history professor Rosa Maria (Leonor Silveira) gives her young daughter, Maria Joana (Filipa de Almeida), mini history lessons by detailing the backgrounds of the monuments and places they encounter. In spite of the stars aboard this vessel (Catherine Deneuve, John Malkovich and Irene Papas), the locations are the film's main attraction. During their voyage, they pass Ceuta before arriving in Marseilles, the first port of call on their Mediterranean cruise. But they do not stay in Marseilles long; France's oldest city is only a stop on their way to Bombay, where Maria Rosa's husband awaits them. While in Marseilles, they come across a small dog, Sooty, who is cruelly tied to the dock in order to moor a boat. The didactism of the opening sequence continues as Rosa Maria speaks to the fisherman Jean. He explains Marseilles' place within the oil industry, and encourages them to read the sidewalk plaque, which refers to the Greeks' founding of Marseilles as a 'cradle of civilization'. This sets up the themes of *A Talking Picture*: a meditation on civilization, East-West relations and 'polyglot interactions'. This scene also introduces Delphine (Deneuve), as Rosa Maria and Maria Joana watch her board the ship. The first half of the film is a travelogue; after Marseilles, the characters continue toward Naples and Pompeii, Athens and its Acropolis, Istanbul (Hagia Sophia), Egypt (the Sphinx) and Aden, the capital of Yemen. De Oliveria's' long-take shots beautifully depict these striking locations. The film's title is appropriate for this travelogue/history lesson, as Rosa Maria constantly answers her inquisitive daughter. **→Zachary Ingle**

Photo © wikicommons

Directed by Manoel de Oliveira
Scene description: 'Marseilles, the cradle of civilization'
Timecode for scene: 0:06:33 – 0:11:14

 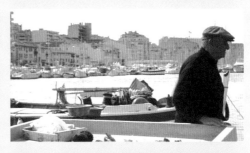

Images © 2003 Madragoa Films, Gemini Films, Mikado Film

LILA SAYS/LILA DIT ÇA (2004)

Passage de Lorette, Rue des Phocéens

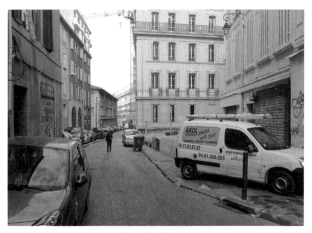

LILA SAYS IS DIRECTOR ZIAD DOUEIRI'S film adaptation of the eponymous novel whose author is known only as his pseudonym, 'Chimo'. The Panier, the oldest *quartier* of Marseilles, features as a rich setting of fantasy and reality under the quasi-ethnographic gaze of Doueiri. After the prologue introduces the protagonists, 19-year-old Chimo (Mohammed Khouas), a second-generation Arab immigrant and gifted writer, and Lila (Vahina Giocante), a 16-year-old orphan of Polish descent living with her mentally ailing aunt, the film opens with a series of shots documenting the cultural identity and diversity of the Panier. As the setting for a dramatic love story, the Panier appears both seductive under the cinematic light of the Provençal sun and oozing darkness through the pores of its rundown buildings. In this scene with the Passage de Lorette in the background, one can get a glimpse of the *quartier* as an enclave of poverty, unemployment and limited horizons, which is under the constant radar of local French police. In the middle of the day, Chimo meets his three Arab friends for a walk that takes them to the Café du Coin where they appear to be regular customers. Their path to the Café du Coin takes the low economic pulse of the *quartier* where, as Chimo's narrative voice-over dubs, 'most prop up the walls in case they fall'. The sidewalks overflow with old clothing, books and appliances for sale; they are a picturesque glimpse of life in the Panier, which, according to Chimo, is 'made of tiny, useless bits.' **➥Oana Chivoiu**

Photos © Gabriel Solomons

Directed by Ziad Doueiri
Scene description: Introducing Chimo's friends: Mouloud, Bakary, Big Jo
Timecode for scene: 0:03:20 – 0:03:40

MARSEILLE (2004)

Consulat Generale d'Allemagne, 228 Avenue du Prado

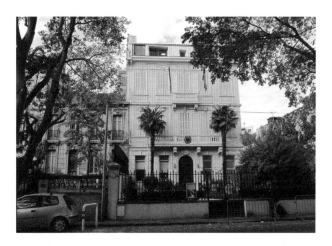

ASKED WHAT SHE PHOTOGRAPHS, Sophie (Maren Eggert), a young German woman, replies, 'streets'. In these concluding scenes of *Marseille* – a film exemplifying the Berlin School's minimalist aesthetic – Sophie tells a police officer that she was robbed at gunpoint shortly after arriving in Marseilles from Berlin. Whereas her previous and mostly uneventful visit to Marseilles was chronicled in the first part of the film, in this sequence, Sophie recounts how her assailant stole her bag and clothes. Initially speaking German, she switches to French, stating, 'I wanted to stay alive. I had to stay alive.' The city's topography is crucial to her testimony, as she traces her steps from the Boulevard des Athènes to La Canebière, near where the attack occurred. Despite her relative familiarity with Marseilles, she still fell prey to its violence. After leaving the station, clad in a police-issued yellow dress, Sophie walks through the very streets she had wandered and photographed during her first stay in Marseilles. She crosses the elegant, historic Avenue du Prado until reaching the German consulate, her figure fading away in the distance. The peacefulness of this leafy boulevard belies the trauma Sophie had just experienced in the city. She is next shown – still wearing the yellow dress – on a beach of the Plages du Prado, filmed in an extreme long shot, starting at sunset. Sophie is barely distinguishable as she walks along the darkened water's edge and away from the camera, her future uncertain. *Marseille*'s façade of minimalist calm conceals a complex universe linking Berlin and Marseilles, where much is left unsaid/unseen – including the attack on Sophie – and which the spectator does not fully grasp upon first viewing the film. **•▸Marcelline Block**

Photo © Gabriel Solomons

Directed by Angela Schanelac
Scene description: Sophie's testimony
Timecode for scene: 1:19:01 – 1:28:32

A GOOD YEAR (2006)

Marseille Provence Airport, Marignane

FEW HOLLYWOOD FILMS RIVAL *A Good Year*'s showcasing of the French countryside, with its scenic photography of several locations in Provence. While many vintages separate Max Skinner's (Russell Crowe) childhood in a Provençal chateau and winery from his later career as an unscrupulous London stock trader, the death of his uncle Henry (Albert Finney) pulls him back to southern France. The return to the chateau will prove life-changing. Max – called 'xenophobic' by director Ridley Scott – despises the leisurely Provençal lifestyle that he had left behind for fast-paced London. Upon his arrival in Marseilles, he is irritated that his assistant made his Hertz rental a Smart car, a much too plebian – not to mention small – vehicle for the wealthy Max. The car's navigation system is a continual source of annoyance, distracting him from the gorgeous landscape. Sunny Provençal vineyards contrast sharply with rainy London and the dreary office there that Max keeps calling. Provençal locations include Fanny's café in Gordes, an idyllic town so French that Fanny (Marion Cotillard) informs tourists that if they don't like her café, 'McDonald's is in Avignon, fish and chips in Marseilles.' An outdoor film screening where Max and Fanny are caught in the rain was filmed around the pond of the village of Cucuron, and the Château la Canorgue where the bulk of the action occurs is in Bonnieux. Max briefly flies out again from Marseille-Provence Airport to London, where he makes the monumental decision to leave the hectic world of high finance for good and return to Fanny and the slower, Provençal life. *A Good Year* depicts a remarkable, although credible, transformation of misanthropic Max. •*Zachary Ingle*

Photo © Gabriel Solomons

Directed by Ridley Scott
Scene description: Arrival in Provence
Timecode for scene: 0:13:08 – 0:13:51

ROBERT GUÉDIGUIAN AND ARIANE ASCARIDE

Text by GEORGIANA M.M. COLVILE

In Conversation

This interview with Marseillais couple Robert Guédiguian and Ariane Ascaride was conducted at their Parisian studios, Rue Jean-Pierre Timbaud, 11th *arrondissement* in February, 2012.

ROBERT GUÉDIGUIAN (B.1953) and Ariane Ascaride (b.1954) were born and raised in Marseilles: Guédiguian hails from l'Estaque, and Ascaride from Notre-Dame-du-Mont, near the city's centre. In the 1970s, they met at the University of Aix-en-Provence, but soon moved to Paris, where she studied at the Conservatoire national supérieur d'art dramatique (French National Academy of Dramatic Arts). She has starred in 16 of his 17 films, starting with *Dernier été/Last Summer* (co-directed with Frank Le Wita, 1981) up until *Les neiges du Kilimandjaro/The Snows of Kilimanjaro* (2011).

Although Guédiguian, the Marseilles film-maker par excellence, often sets his films at l'Estaque, humorously claiming to be a 'local' director, he believes that any location becomes universal as the

background for contemporary screen fiction in its consideration of social problems. Simultaneously, he acknowledges the unique aesthetic of l'Estaque's hills rolling down to the sea, which has inspired many painters. He shares the community's pride in its landscape. When acting in Marseillais films, Ascaride avoids folkloric performances and the local tendency toward self-caricature, concentrating instead on expressing her character's authenticity, regardless of place and origin.

Guédiguian's attitude toward Pagnol fluctuates, remaining ambiguous. Pagnol's worldwide popularity as a (southern) French director can be a heavy burden. Guédiguian, who is strongly committed to left-wing ideology, disagrees with Pagnol's more right-wing politics. However, he does admire the old master, a pioneer of the talkies, one of the first to treat dialogue as action and to shoot outdoor scenes on location. He occasionally nods to Pagnol, such as with the card-playing scene in *Kilimanjaro*, an intertextual reference to the well-known card-playing scene in Pagnol's *Marius* (Alexander Korda, 1931).

Concerning the remarkably harmonious dual structure of Guédiguian's films, which combine a moral/political statement with a romantic/poetic story, the director admits that the key to achieving that balance is to favour narrative and emotions. He emphasizes the importance of embodying ideas as opposed to expressing them through theoretical dialogue. He states that the process was never spontaneous, but intricately elaborated in a 'Machiavellian' vein. From the actor's point of view, Ascaride maintains that the text initially must be mastered – 'swallowed' – so that she can fully lend her voice and body to her character. This process facilitates the spectator's 'introspective emotional response' (Ascaride).

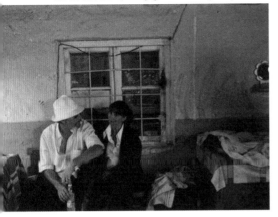

When I asked them if they liked Marseillais writer Jean-Claude Izzo (1945–2000), they answered jointly: 'Yes!' Izzo and Guédiguian were friends, worked for television together, and Izzo inscribed occasional references to Guédiguian's films into his novels. According to Guédiguian, the two men had a similar vision of Marseilles: a perpetual melting pot, built on the ideas of mixture and *métissage* (miscegenation). Guédiguian pointed out that if nowadays most big cities are cosmopolitan, the port of Marseilles has always been a frontier town, a gateway to the world, a *ville-monde*. One has to think of Marseilles *du côté de la mer* in terms of the sea and nostalgia for faraway places. And yet, says Ascaride, many Marseillais turn their backs on the sea and look to the land, which reminds Guédiguian of the village shopkeepers' world in Pagnol's trilogy, except for certain characters like Marius. Indeed a lyrical, yet physical love of the sea permeates most of Izzo and Guédiguian's works.

Guédiguian has an ambiguous view of racism in this port city, where so many different people co-exist. Although he acknowledges the large contingent of Front National voters and the anti-Arab postcolonial *pieds noirs*, he claims that Paris, with its *cités* (suburban housing developments), is worse. Guédiguian and

Although Guédiguian, the Marseilles film-maker par excellence, often sets his films at l'Estaque... he believes that any location becomes universal as the background for contemporary screen fiction in its consideration of social problems.

Ascaride discussed their mixed backgrounds and how they consider it a plus to be polyglot, multinational Marseillais. Ascaride is half Italian (Neapolitan) and half French (from the Ariège), and Guédiguian is half Armenian, half German. He hates the concept of 'pure' blood (such as promulgated by Aryan ideology) and the jingoistic notion of an individually 'great' country. A diversity of origins is made apparent in the opening scene of *Kilimanjaro*, as the dockworkers' names are called out, as well as in the motley characters of Izzo's novels – especially the Fabio Montale trilogy – that are mainly pan-Mediterranean.

Whether working with one's partner on a film makes things easier or more difficult, Ascaride believes it is both, adding that mutual respect is fundamental. She accepts that on a film set the director is the boss, while Guédiguian insists that the actors are more important to the public. He does agree that today film influences literature, notably fiction, and that Izzo's novels, for example, are cinematic.

Guédiguian's films' idealization of love, couplehood and lasting relationships – including friendship – is particularly emphasized in *Marius et Jeannette/Marius and Jeannette* (1997), *Marie-Jo et ses 2 amours/Marie-Jo and her 2 Lovers* (2002) and *Kilimanjaro* (2011). He says that these values are necessary for him and, therefore, he adheres to them; equality between men and women is of fundamental importance to him, and states that he and Ascaride have grown up together professionally as well as personally. Indeed, Guédiguian sees significant relationships in much the same light as creativity: it is hard work to sustain couplehood or make friendship last, both most worthwhile endeavours. His favourite actors and actresses form a well-established team of close-knit friends, of whom the main ones are the trio Ascaride, Jean-Pierre Daroussin (b. 1953) – her fellow student at the Conservatoire – and Gérard Meylan (b. 1952), Guédiguian's childhood friend from l'Estaque. When Daroussin was asked if they rehearse before filming, he replied: 'We've been rehearsing for 30 years!' – a wonderful phrase quoted by Ascaride.

Regarding his next film, Guédiguian said it is much too soon to make another one about l'Estaque just after *Kilimanjaro*, but that there will be more in the future. He is now planning a very sober feature, a conversation between two people about the Armenian genocide, entirely different from his previous *Armenia* (2006). ✣

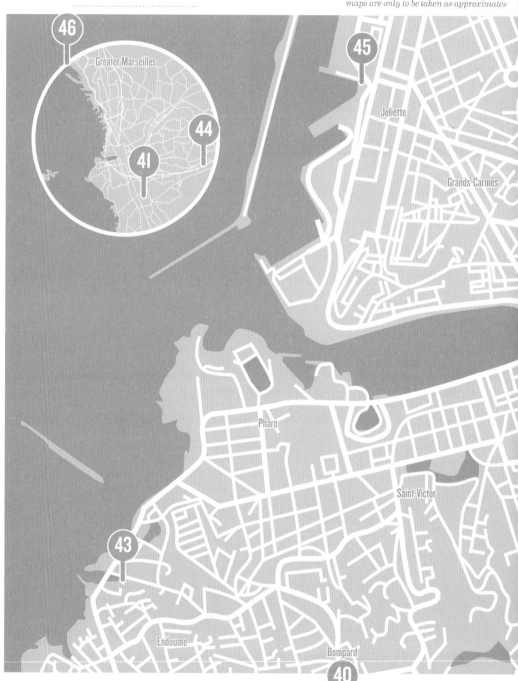

MARSEILLES LOCATIONS
SCENES 40-46

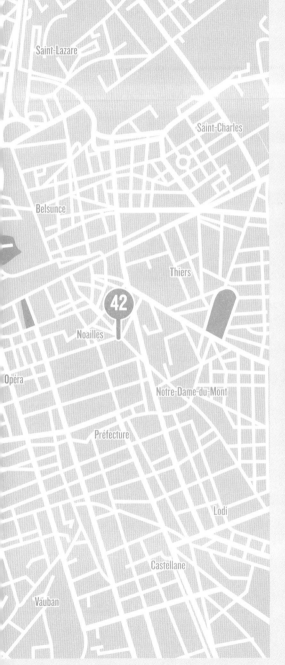

40.

THE SECOND WIND/
LE DEUXIÈME SOUFFLE (2007)
Calanques de Marseille
page 110

41.

TAXI 4 (2007)
Stade Vélodrome, 3 Boulevard Michelet
page 112

42.

THE LAST DEADLY MISSION/
MR 73 (2008)
Pedestrian Bridge above the Cours
Lieutaud linking the rue Estelle to the
cours Julien
page 114

43.

TRAITOR (2008)
Vallon des Auffes,
Escalier du Vallon des Auffes
page 116

44.

A PROPHET/UN PROPHÈTE (2009)
A50 Highway near La Valentine
page 118

45.

22 BULLETS/L'IMMORTEL (2010)
Port de Marseille Fos,
23 Place de la Joliette
page 120

46.

THE SNOWS OF KILIMANJARO/
LES NEIGES DU KILIMANDJARO (2011)
The docks at l'Estaque
page 122

THE SECQND WIND/
LE DEUXIÈME SOUFFLE (2007)

LOCATION *Calanques de Marseille*

MANY OF THE LOCATIONS AND SETS of Corneau's 2007 remake of Jean-Pierre Melville's classic heist film *Second Breath* (1966) take place at night in a dark, murky and claustrophobic atmosphere. An air of tension and uncertainty hangs over these intense, noirish scenes. This seaside encounter of Antoine (Nicolas Duvauchelle) and Stanislas Orloff (Jacques Dutronc) is a jarring shift in the film's visual style. The two characters make arrangements for an evening meeting between the criminals whom they are representing. Their conversation is eclipsed by the early afternoon light in shades of yellow and orange – although it seems to have been filmed at dusk, during the so-called 'magic hour' – evoking 1960s southern France, and the natural beauty of the limestone cliffs juxtaposed with the dark blue waters of a Mediterranean cove. The scene takes place along the Calanques (inlets) of Marseilles to the south-east of the city's centre, between Marseilles and Cassis, in the 8th *arrondissement*, near the fishing village of Les Goudes, with dramatic valleys tumbling into the sea. The isolation of the location suggests the sensitivity of the business being conducted, as well as paralleling the closed-off nature of the characters and the privacy that they seek in vain. Spectators can imagine this area as a possible escape from France for protagonist Gu (Daniel Auteuil) and Manouche (Monica Bellucci), who seek freedom in Italy. However their dream is destroyed by a dramatic shootout between Gu and the police in a tenebrous Marseilles apartment building.
↤ Lance Lubelski

Directed by Alain Corneau
Scene description: Antoine meets Orloff along the coast
Timecode for scene: 1:45:39 – 1:46:47

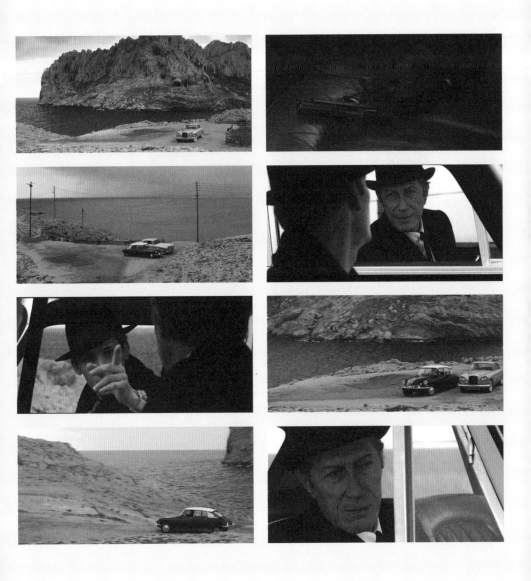

TAXI 4 (2007)

THE FARCICAL ELEMENTS OF the *Taxi* series reach their peak in this buddy comedy, the third directed by Krawczyk, and the fourth written/produced by action auteur Luc Besson. This time, football superstar Djibril Cissé is the celebrity rider in Daniel's (Samy Naceri) taxi (a Peugeot 407, making its debut in the series). Cissé's police escort to the big charity game ends in a wreck, so who can get him to the stadium on time? Why, Daniel, of course! Daniel's taxi takes over, as the whole city is abuzz about Cissé's transfer to the Olympique de Marseille club. It is fitting that Émilien (Frédéric Diefenthal) rides with them, as the homosocial relationship between him and Daniel is emphasized over the relationships with their respective wives and children throughout this film. Frustrated with the parking garage, Daniel drives right onto the pitch of the Stade Vélodrome, as the fans go wild. A man of intestinal fortitude, Cissé does not get sick from Daniel's Formula 1-type speed. 'Misirlou' begins as the credits roll, and we have ourselves another *Taxi* movie. Without Marion Cotillard, extra star power was needed for this fourth entry in the increasingly formulaic *Taxi* franchise. Cissé, likely given the role because of the recent transfer, has no relevance to the plot and will not be seen again, even in the film's finale, which fittingly closes with the Stade Vélodrome. This comedically overdone installment in the *Taxi* series involves a Belgian criminal (reputed as the world's most notorious) and a finale that sends the franchise out with a bang. ⁕*Zachary Ingle*

Photo © Gabriel Solomons

Directed by Gérard Krawczyk

Scene description: Football star Djibril Cissé arrives in Marseilles
Timecode for scene: 0:08:57 – 0:09:21

THE LAST DEADLY MISSION/MR 73 (2008)

Pedestrian Bridge above the Cours Lieutaud linking the rue Estelle to the cours Julien

OLIVIER MARCHAL'S LOOSELY autobiographical police drama opens with haggard Detective Louis Schneider (Daniel Auteuil) taking a Marseilles bus hostage, and soon after telling a fellow cop that God is a 'son of a bitch' whom he wishes to kill. This despairing tone is maintained throughout the film by its bleak subject matter, as well as cinematography that captures the cool and sombre appearance of many of Marseilles' centuries-old neighborhoods' narrow streets and graffiti-covered façades, which reveal horrors. The mutilated corpses of women are being found in residences all over Marseilles in a series of gruesome attacks. Schneider simultaneously investigates these killings while helping Justine (Olivia Bonamy) track down the man who murdered her parents when she was a child, nearly thirty years before the film's narrative begins. Justine seeks out Schneider in Marseilles' 6th *arrondissement*. Inside the stairwell of his apartment building, Schneider initially rejects Justine's plea for assistance, only to later catch up to her on the *passerelle* (pedestrian bridge) above Cours Lieutaud. The film's clear lighting and monochrome colour palette, even in night-time scenes such as this one, belie the intense emotions and fears churning within Justine and Schneider.
•◦ Lance Lubelski

Directed by Olivier Marchal
Scene description: *Justine finds and speaks to Schneider*
Timecode for scene: *1:08:04 – 1:09:10*

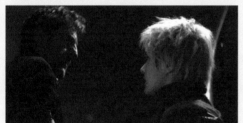

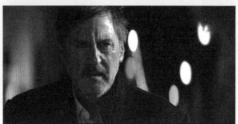

TRAITOR (2008)

LOCATION *Vallon des Auffes, Escalier du Vallon des Auffes*

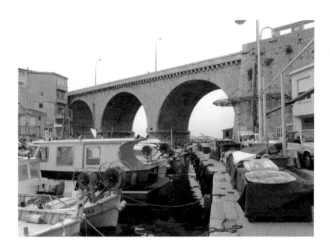

SAMIR HORN (DON CHEADLE) is a former US Army Special Forces expert in explosives and a devout American Muslim. An Arab-speaking US citizen of Sudanese descent, he is involved in selling explosives to jihadis and Islamic radicals in the Middle East. A firm believer in the Holy Quran, he joins the terrorists' cause while both the FBI and a rogue CIA agent track him around the world, since he has been placed on the FBI's list for being found in the vicinity of terrorist bombings. Samir escapes a Yemeni prison, re-locates to France and goes underground in the multicultural city of Marseilles to elude US authorities, and also to prove his skills at explosives with a gruesome bombing. But 'truth is complicated', since Samir also, for many years, was on the CIA's payroll and infiltrated the Islamic terror network as an undercover agent. His loyalities and identity seem to be in constant conflict throughout the diegesis of this spy thriller. On the small port side of Vallon des Auffes in Marseilles, dubious Samir walks down the *escalier* (stairway) to meet Omar (Saïd Taghmaoui) and to suggest, after a failed attempt at a bombing, to go forth with a terror attack on the American consulate in Nice, stating ominously, 'We have to start over.' Here, Marseilles is portrayed as a conflicted site, a transitional space for newcomers and immigrants. The historic Mediterranean habitat is shown to be a zone of contrasting cultural identities, diverging loyalties and global conspiracies. **➻Pamela C. Scorzin**

Directed by Jeffrey Nachmanoff
Scene description: 'We have to start over'
Timecode for scene: 0:45:14 – 0:46:16

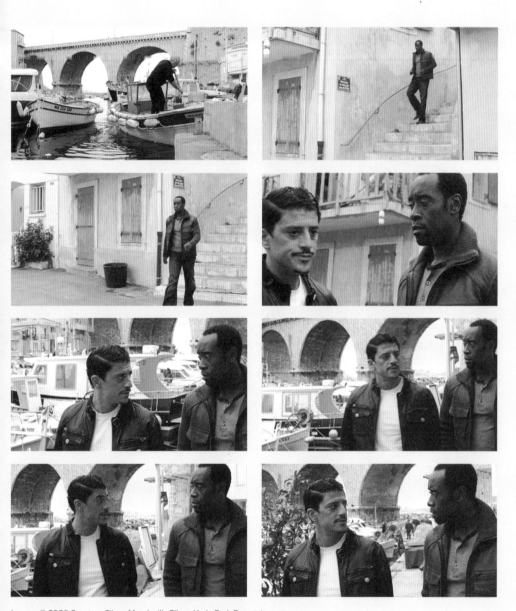

Images © 2008 Overture Films, Mandeville Films, Hyde Park Entertainment

A PROPHET/UN PROPHÈTE (2009)

A50 Highway near La Valentine

MALIK EL DJEBENA (TAHIR RABIM) began *A Prophet* as a clueless teenaged convict; by this scene, he is negotiating with an Arab mob boss on behalf of the incarcerated Corsican crime lord under whose protection he has been operating in Brécourt Prison. The crimes committed by that Corsican crime lord were so severe he may never be released, and so he has Malik act as a 'model prisoner' in order to earn leave days. These are 12-hour stretches of freedom Malik is supposed to use to aid his rehabilitation and to train as car mechanic, but that can instead be spent running criminal errands. Arriving at the Marseille-Provence Airport after his first ever flight, Malik is met by the henchmen of Brahim Lattrache (Slimane Dazi), pulled into their car and searched as they drive away. Eventually, the driver stops on a clifftop road overlooking Marseilles. Lattrache enters the car and talks begin. They seem to be going well, until Lattrache puts a gun to Malik's head and demands to know what happened to a friend of his, named Reyeb, who died in Brécourt a couple of years earlier. What we know but Lattrache does not is that Malik cut Reyeb's throat. The spot where the car pulls over is scenic and serene. Beneath it, Marseilles looks like an image on a postcard; we can imagine tourists posing here for snapshots. In this setting, the violent events inside the car seem completely incongruous. **•• Scott Jordan Harris**

Directed by Jacques Audiard
Scene description: Malik meets Brahim Lattrache
Timecode for scene: 1:39:58 – 1:42:50

 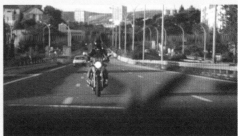

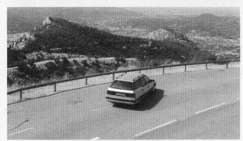 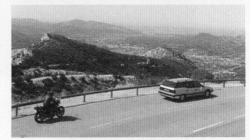

 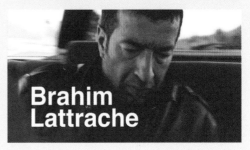

22 BULLETS/L'IMMORTEL (2010)

LOCATION *Port de Marseille Fos, 23 Place de la Joliette*

RICHARD BERRY'S L'IMMORTEL focuses on Charly Matteï (Jean Reno), a retired mobster who survives 22 bullets in an attempted assassination. While the police and Matteï's mafia connections investigate the assault, Matteï repeatedly confesses his desire to live in peace with his family. During an interrogation in an empty warehouse in the grand Grand Port Maritime of Marseilles, it is revealed that the hit was ordered by Matteï's old friend and current mafia boss, Tony Zacchia (Kad Merad), who objects to Matteï's moralistic stance on drug trafficking. The scene begins with a nod to mafia film genre conventions: there is a snitch, a cement-filled bucket, angry gangsters and abandoned docks. Yet, at this port the unexpected happens. Instead of a gunshot and a dead snitch, there is a ship's horn and a meditative Matteï listening to the waves and seagulls. After staring out at the passing ships, Matteï quietly announces he will respect his former friendship with Zacchia by not starting a war. Life, he says, is more important than honour. He leaves the docks and, he hopes, the mafia behind. Zacchia, however, is not content to let Matteï retire, and orders one of his men killed and his son kidnapped. Filled with righteous anger, Matteï guns down the would-be assassins, rescues his son and engages in a final showdown with Zacchia. The concluding moments of the film, with Matteï and his reunited family together on the beach, confirm his earlier thoughts back at the port: there is nothing as sacred as family. ↝***Katherine A. Wagner***

Photo © Isabelle Marcangeli

Directed by Richard Berry
Scene description: Interrogation in an empty seaport warehouse
Timecode for scene: 0:35.30 – 0:40.31

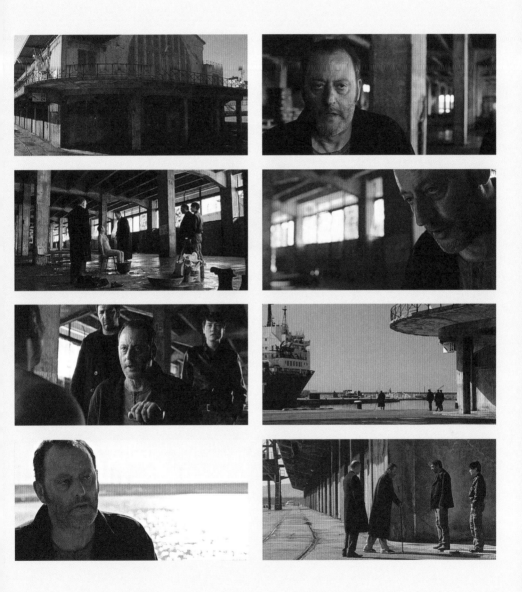

THE SNOWS OF KILIMANJARO/
LES NEIGES DU KILIMANDJARO (2011)

LOCATION *The docks at l'Estaque*

THIS FILM OPENS WITH A LONG SHOT of l'Estaque's industrial port. In the foreground, on the dock, a semi-circle of workers in blue denims face a whitish sea. Immediately opposite, three men at a table: union-leader Michel (Jean-Pierre Daroussin) is calling out names, drawn from a box; his friend Raoul (Gérard Meylan) announces each number, while a third makes a list. Depth of field shows the far side of the harbour, with cranes and dirty grey hangars against a blurred city skyline. Two anchored trawlers form a dividing line between men and water, and their names contribute to the gloomy atmosphere: CAMARGUE, the wild marshland refuge for Romani and Spanish revolutionaries at the Rhône delta, where Paul Carpita shot a strike film, *Les Sables mouvants/The Moving Sands* (1996), and MISTRAL, the violent, Provençal northerly wind, especially dangerous at sea. Suspense becomes palpable as Michel reveals all twenty frequently foreign patronyms – typical of Marseilles' melting-pot – of those dismissed to the anxious dockers, the last being Michel's own, along with that of young Christophe Brunet (Grégoire Leprince-Ringuet), a crucial character in the plot. During the sequence, the camera tracks along the waterfront and zooms in with close-up shots of various groups of workers, people watching and Michel's trio. This ominous, all-male scene ends with a sympathetic Michel addressing his 'comrades', in a vain attempt to be comforting. Ironically, the next sequence on the docks will be of an ephemerally happy, anniversary party. **↝Georgiana M.M. Colvile**

Photo © P. Caracchioli

Directed by Robert Guédiguian
Scene description: 20 workers made redundant on the docks
Timecode for scene: 0:00:47 – 0:02:47

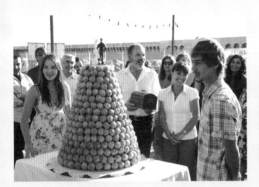

Images © 2011 Agat Films & cie., Canal+, France 3 cinéma

GO FURTHER

Recommended reading and useful resources

BOOKS

César
(especially chapter 4, 'Marseille', pp. 57-79)
by Stephen Heath
(London: BFI Publishing, 2004)

The French Connection:
A True Account of Cops, Narcotics, and
International Conspiracy
by Robin Moore
(Boston : Little, Brown, and Co., 1969)

Jean Epstein:
Critical Essays and New Translations
Sarah Keller and Jason Paul, eds.
(Amsterdam University Press, 2012)

Marcel Pagnol
by Brett Bowles
(Manchester: Manchester University Press, 2012)

Marseille, porte du Sud
by Albert Londres
(Monaco: Le Serpent à Plumes, 1995 [first ed.: 1927])

ARTICLES AND BOOK CHAPTERS

'Hybridity, Space and the Right to Belonging:
Maghrebi-French Identity at the Crossroads in
Karim Dridi's *Bye-Bye*'
by Will Higbee
In L. Mazdon (ed), *France on Film: Reflections on
Popular French Cinema*
(London: Wallflower, 2001)
pp. 51-64

'In the name of the father:
Marcel Pagnol's 'trilogy': *Marius* (1931),
Fanny (1932), and *César* (1936)'
by Ginette Vinceneau
In Susan Hayward and Ginette Vincendeau
(eds.), *French Film: Texts and Contexts* (London
and New York: Routledge, 1990)
pp. 67-81

'Paris: City of the Imagination'
by Keith Reader
In Marcelline Block (ed), *World Film Locations:
Paris* (Bristol: Intellect/Chicago: University of
Chicago Press, 2011)
pp. 6-7

'La porte'/ 'The Door'
by Guillaume Apollinaire
In *Selected Poems: Apollinaire*,
trans. Olivier Bernard
(London: Anvil Poetry Press, 2004)
p. 72

FILMS

Melville-Delon: d'honneur et de nuit /
Melville-Delon: Of Honor and Of Night
Olivier Bohler, dir.
(France: Nocturnes Productions, 2011)

Sous le nom de Melville /
Code Name Melville
Olivier Bohler, dir.
(France: Nocturnes Productions, 2008)

Un de la Canebière /
One from the Canebière
René Pujol, dir.
(France: Gray-films, Vondas Films, 1938)

ONLINE

'Marseille Provence:
European Capital of Culture 2013'
http://marseillecityofculture.eu/

'Provence : The Ten Best Films'
http://bit.ly/c1zq4p

CONTRIBUTORS

Editor and contributing writer biographies

EDITOR

MARCELLINE BLOCK (BA, Harvard; MA, Princeton; Ph.D. candidate, Princeton) has taught at Princeton as a Lecturer in History. Publications include: *World Film Locations: Paris* (2011); *World Film Locations: Las Vegas* (2012); *Situating the Feminist Gaze and Spectatorship in Postwar Cinema* (2008, 2010), awarded Book of the Month by Cambridge Scholars Publishing (January 2012) and translated into Italian (2012). Co-editor of *Unequal before Death*, published with a grant from Columbia University (Book of the Month, September 2012, Cambridge Scholars Publishing); *Gender Scripts in Medicine and Narrative* (2010); *Critical Matrix: The Princeton Journal of Women, Gender, and Culture* (volume 18, 2009). Her articles and book chapters about film, literature, and visual art appear in French, Korean, and Russian. She frequently lectures, including about Paris in Film at 92Y TriBeCa, New York City.

CONTRIBUTORS

ELIZABETH ABELE is an Associate Professor of English at SUNY Nassau Community College and Executive Director of the Northeast Modern Language Association. Her essays on American culture and masculinity have appeared in *Images, American Studies, Journal of American and Comparative Cultures, College Literature* and *Scope*, and in the edited anthologies *Best American Movie Writing 1999* (St. Martin's Press, 1999) and *Critical Approaches to the Films of M. Night Shyamalan* (Palgrave, 2010).

ADRIENNE ANGELO is Associate Professor of French at Auburn University. She specializes in contemporary women's writing in French and the francophone world, and also has a keen interest in French and francophone cinema. She has published on writers Nina Bouraoui, Camille Laurens, Catherine Millet and Nathalie Rheims, as well as film-makers Catherine Breillat and François Ozon. Most recently, she co-edited a collection of critical essays, *Cherchez la femme: Women and Values in the Francophone World* (Cambridge Scholars, 2011). At Auburn University, she teaches a course on the history of French cinema and organizes the French Film Series. This event is sponsored by the Department of Foreign Languages and Literatures and screens four French films each semester. In 2011, she and her colleague, Dr. Giovanna Summerfield, received a grant from FACE (French American Cultural Exchange), in partnership with the Cultural Services of the French Embassy, to host the Tournées French Film Festival.

HENRI-SIMON BLANC-HOÀNG holds a Ph.D. (2005) in Latin American literature from the University of Florida. He began his teaching career in 1994, and since 2007 has taught Spanish, French, Latin American literature and Francophone Studies at the Defense Language Institute in Monterey/Seaside, California. Blanc-Hoàng's research interests include Film Studies, Postcolonial/ National and Globalization Studies, Graphic Novels, and Science Fiction Studies. In addition to contributing to the *World Film Locations* book series, he has written a chapter for the *Comics as History, Comics as Literature* anthology (Rowman & Littlefield, 2012). Blanc-Hoàng is now working on a new article on science fiction in the Latin American graphic novel that will be included in the *Brown and Black Planets* collection of essays.

OLIVIER BOHLER (b. 1972, Marseilles) completed his studies in literature and film in 2000 at the Université Aix-Marseille, with a doctoral dissertation on Jean-Pierre Melville entitled 'Vestiges de soi, vertige de l'autre: l'homme de l'après guerre dans le cinéma de Jean-Pierre Melville'. He is also a recognized specialist of Pier Paolo Pasolini, and has published numerous essays and magazine articles about the history of film. Since 2005, he has written scripts for various French films and TV series, and in 2007 he co-founded the film production company Nocturnes Productions. After the 2008 release of *Code Name Melville*, his first feature-length documentary, his second documentary, entitled *Jean-Luc Godard, Le Désordre Exposé*, appeared in 2012.

OANA CHIVOIU is a Ph.D. candidate in Theory and Cultural Studies at Purdue University where she completes her dissertation on literary crowds during the Victorian era. Her research interests include Victorian Studies, film criticism, postcolonial literatures and post-communism. She has been a contributor to Paris and Las Vegas volumes of the *World Film Locations Series, Film International* and *Short Film Studies*.

GEORGIANA M. M. COLVILE is Professor Emeritus of Anglophone Studies at the University of Tours, France. She has taught French, francophone and comparative literature and film at the University of Colorado, Boulder, among other American universities. She specializes in francophone and anglophone avant-garde and contemporary literature, art and film, particularly by women. Her four latest books focus on women surrealists: *Scandaleusement d'elles* (anthology: Jean-Michel Place, 1999); editions of the works of Valentine Penrose (Joëlle Losfeld, 2001) and ➡

Simone Kahn-Breton (Joëlle Losfeld & Gallimard, 2005) and, with Katharine Conley, *La Femme s'entête* (proceedings of their 1997 Cerisy conference *La Part du feminin dans le surréalisme*: Lachenal & Ritter, 1998). Colvile was a participant at the Agnès Varda conference at the University of Rennes, France (2007), and has taught and published widely on film, especially French, Irish and American.

JEZ CONOLLY holds an MA in Film Studies and European cinema from the University of the West of England, and is a regular contributor to The Big Picture magazine and website. Jez comes from a cinema family: his father was an overworked cinema manager, his mother an ice-cream-wielding usherette and his grandfather a brass-buttoned commissionaire. Consequently he didn't have to pay to see a film until he was 21, and having to fork out for admission still comes as a mild shock to this day. Jez has co-edited two volumes in the World Film Locations series, covering Dublin and Reykjavik. He is currently working on a third (Liverpool) and a monograph about John Carpenter's The Thing. In his spare time he is the Arts and Social Sciences & Law Faculty Librarian at University of Bristol.

SANDY FLITTERMAN-LEWIS is an Associate Professor in the English department at Rutgers University, where she teaches courses in Cinema Studies and comparative literature. Her book, *To Desire Differently: Feminism and the French Cinema* (Columbia University Press, 1996), treats three French women directors from the standpoint of feminist film theory. She is the co-author of *New Vocabularies in Film Semiotics* (Routledge, 1992), as well as the author of numerous essays in anthologies and journals. Her current work, *Hidden Voices: Childhood, the Family, and Anti-Semitism in Occupation France*, deals with material culture and daily life for Jewish families during World War II and its aftermath.

MARCO GROSOLI is a postdoctoral fellow at the University of Kent (Film Studies department). He has co-edited (with Monica Dall'Asta) a book on Guy Debord's cinema, and is preparing a monograph on the 'Politique des auteurs' film critical wave. He has published on several collections and journals, including zizekstudies.org, *Fata Morgana* and *Journal of Adaptation in Film and Performance*. As a film critic, he regularly collaborates with various Italian reviews and websites, including *Film Comment*, *La furia umana*, *Sentieri Selvaggi*, *Close-Up* and *FilmIdee*.

KRISTIINA HACKEL is an Associate Professor of Film, Screenwriting, Television, and Media Studies at California State University, Los Angeles. She holds a Ph.D. in comparative literature and an MFA in film production from the University of Southern California. A screenwriter and award-winning film-maker, her last directing project, *Speedie Date*, was nominated for a 2009 Webby Award.

SCOTT JORDAN HARRIS is a British arts journalist and sportswriter. Formerly editor of *The Spectator*'s arts blog and *The Big Picture* magazine, he is a culture blogger for *The Daily Telegraph*, a contributor to BBC Radio 4's *The Film Programme* and UK correspondent for Roger Ebert. His writing has been published in more than a dozen books on film and by, among others, *Sight & Sound*, *The Spectator*, *The Guardian*, *Fangoria*, Film4.com, BBC online, *Rugby World*,

Film International and *The Huffington Post*. He is also editor of the *World Film Locations* volumes on New York, New Orleans, Chicago and San Francisco; and in 2010 his blog, *A Petrified Fountain*, was named by RunningInHeels.com as one of the world's best film blogs. He is on Twitter as @ ScottFilmCritic.

ANDREW HOWE is an Associate Professor of History at La Sierra University, where he teaches courses in film history and theory, popular culture and American history. Recent publications include articles on race and racism in *Star Wars*, and Maya Deren's construction of the female body in her avant-garde films. Current research projects involve the rhetoric of fear employed during the 1980s killer bee invasions of the American south-west, as well as the debate over the rediscovery of the Ivory-billed Woodpecker in Arkansas. These two works are conceived of as chapters in a book-length project exploring the manner in which societies translate environmental events by employing the familiar rhetorical strategies and vocabularies of existing, sociological problems.

ZACHARY INGLE is a Ph.D. student in Film and Media Studies at the University of Kansas. He holds degrees from Howard Payne University, Baylor University and North Carolina A&T State University. Ingle has published articles and reviews in *Literature/Film Quarterly*, *Mass Communication and Society* and *Journal of American Culture*, among others. He has edited *Robert Rodriguez: Interviews* (University Press of Mississippi, 2012) and is currently co-editing (with David M. Sutera) an anthology on sports documentaries. He has contributed to several Intellect books, including the *World Film Locations* volumes on Paris and Las Vegas, the *Directory of World Cinema* volumes on Sweden and Belgium, and the *Fan Phenomena* book on *Star Wars*.

ANNETTE INSDORF is Director of Undergraduate Film Studies at Columbia University. She is the author of *Double Lives, Second Chances: The Cinema of Krzysztof Kieslowski* (Miramax Books, 1999); *François Truffaut* (Cambridge University Press, 1995), a study of the French director's work; *Indelible Shadows: Film and the Holocaust* (Random House, 1983), whose updated third edition (Cambridge University Press, 2003) received the National Board of Review's William K. Everson Award in Film History; and *Philip Kaufman* (University of Illinois Press, 2012). Her commentaries can be heard on numerous DVDs, including Kieslowski's *Trzy kolory/The Three Colors Trilogy* (1993-94), and she has interviewed over one hundred film celebrities in her popular 'Reel Pieces' series at Manhattan's 92nd Street Y.

NATHALIE KATINAKIS holds a Ph.D. in Communication Studies from the University of Quebec in Montreal. Her research interests include French cinema, modern Greece (history, music, culture), collective memory, popular music, hero worship and popular culture in general. Author of the book *Mélina Mercouri et Mikis Théodorakis: les derniers héros grecs* (L'Harmattan, 2011), she is also a scholar of Marcel Pagnol and Robert Guédiguian, whose films she analyzed in her master's thesis.

JEAN-LUC LIOULT is a professor at the University of Aix-Marseille, where he holds the Chair of Documentary Film-making. He has headed the section of Film Studies and the Department of Theatre Arts, and currently directs the collection 'Hors Champ' of the University Presses of Provence. His research interests include the epistemology of the documentary; the representation of cultural identities in film; televisual forms; realism in film (especially in the war film); and the intersections of technology, aesthetics and ideology. He has published *A l'Enseigne du Réel* (PUP, 2004), edited *Des mouvants indices du monde* (PUP, 2008) and translated William Guynn's *A Cinema of Nonfiction* into French, which was published as *Un cinéma de non-fiction* (PUP, 2001). He is also a photographer and a videographer.

LANCE LUBELSKI is a Ph.D. candidate in the history of early modern Germany at the University of Illinois at Urbana-Champaign. His dissertation project concerns the roles of elite and non-elite women in Reformation-era German medicine. He holds an MA from the University of Cincinnati (2009) and a BA from Kent State University (2006). He has presented conference papers on sixteenth-century Spanish theologian Michael Servetus, and he has written on many aspects of international cinema, including a book review of Brian Price's *Neither God Nor Master: Radical Politics and Robert Bresson* (University of Minnesota Press, 2011), as well as contributions to the *World Film Locations* volumes on Paris and Las Vegas. Additionally, he has published on the Radical Reformation, modern physics, Mozart and German wonder books. Finally, he has been awarded a DAAD grant to research in Stuttgart in 2012 and 2013.

REBECCA PRIME is the Libman Professor of the Humanities and Assistant Professor of Art at Hood College, where she also directs the Center for the Humanities Colloquium. She holds a Ph.D. in Cinema and Media Studies from UCLA and an MA from NYU. A film historian whose research interests include transnational American and European cinema, her work has appeared in numerous journals including *Film Quarterly* and *Film History: An International Journal* along with the edited volumes *'Un-American' Hollywood: Politics and Film in the Blacklist Era* (Rutgers University Press, 2007) and *World Film Locations: Paris* (Intellect, 2011). She is the editor of *Cinematic Homecomings: Exile and Return in Transnational Cinema* (Continuum Books, forthcoming) and *Intimate Strangers: Hollywood Exiles in Postwar Europe* (Rutgers University Press, forthcoming).

ZACHARIAH RUSH was born in Manchester, England. He is a prize-winning poet, film-maker, screenwriter and film critic. He has contributed to seven volumes of the *Directory of World Cinema*, and three volumes of the *World Film Locations* series (all Intellect Ltd), as well as regularly contributing book and film reviews to *Film Int.* magazine. He is the author of the book *Beyond the Screenplay: A Dialectical Approach to Dramaturgy* (McFarland & Co.) and currently lives in San Jose, California, where he is adapting Albert Camus' novel *L'étranger* into a libretto for operatic performance for Gallimard, Paris.

PAMELA C. SCORZIN; art, design and media theorist, born 1965 in Vicenza (Italy), is Professor of Art History and Visual Culture Studies at Dortmund University of Applied Sciences and Arts, Department of Design (Germany). She studied European art history, English and American literature and history in Stuttgart and Heidelberg. She received an MA (1992) and a Ph.D. (1994) in art history at the Ruprecht-Karls-Universität in Heidelberg and was an assistant professor in the Department of Architecture at Darmstadt University of Technology from 1995 to 2000. After completing her 'habilitation' in history and theory of modern art in Darmstadt in 2001, she stood in for Chairs in Art History and Visual Culture in Siegen, Stuttgart, and Frankfurt am Main. Since 2005, she is a member of the German section of AICA. Her current areas of research are contemporary art, global design art, fashion and scenography. She has published on art-historical as well as cultural-historical topics from the seventeenth to the twenty-first century. She lives and works in Dortmund and Milan.

STEVEN UNGAR is Professor of Cinema and Comparative Literature at The University of Iowa, with additional appointments in French and Francophone World Studies and International Programs. His recent teaching includes courses on modern French poetry, everyday life, New Wave France, documentary, film and France in the 1930s and film noir. His research activities include articles on Jean-Paul Sartre, Francis Ponge, Louis-René des Forêts, Jean Paulhan, Georges Bataille, Jean Dubuffet, Coluche, Robert Guédiguian, Jean Rouch, Patrick Modiano, W.G. Sebald, Milan Kundera, Jean Vigo, André Bazin, Jonathan Littell and Alain Resnais. Ungar's book-length publications include *Roland Barthes: The Professor of Desire* (University of Nebraska Press, 1983); *Scandal & Aftereffect: Blanchot and France Since 1930* (University of Minnesota Press, 1995); *Popular Front Paris and the Poetics of Culture* (Belknap Press of Harvard University Press, 2005, with Dudley Andrew); and *Cléo de 5 à 7* (BFI Film Classics, 2008). He is completing a study of social documentary in France. He received a 2012 Guggenheim Fellowship for Film, Video and Radio Studies.

KATHERINE A. WAGNER is currently working on her Ph.D. in humanities at the University of Louisville in Kentucky. Her current interdisciplinary research interests within the genres of fantasy and horror focus on the intersections of identity, humanist geography and the carnivalesque. She is the co-author of a paper analyzing the role of place with young adult dystopian novels. In her dissertation work, Katherine is exploring the significance of placelessness within American horror literature and film, and the ways this condition of placelessness contributes to the disruption of reality central to the genre's core. Katherine is also a published author of fiction under the name Katherine A. W. Troyer.

TINA WASSERMAN has a Ph.D. in Cinema Studies from New York University and is a faculty member in the Visual and Critical Studies Department at Tufts University/ The School of the Museum of Fine Arts, Boston. Her essays include 'Constructing the Image of Postmemory' in *The Image and the Witness* (Wallflower Press, 2007), and 'Intersecting Traumas: the Holocaust, the Palestinian Occupation and the Work of Israeli Journalist Amira Hass' in *Culture and Conflict: Contemporary Perspectives on War* (Cambridge Scholars Press, 2007). Other publications are included in, among others, *Screen, Afterimage, Senses of Cinema* and are forthcoming in *Quarterly Review of Film and Video*.

FILMOGRAPHY

All films mentioned or featured in this book